Wedding Pictures

A NOVEL

paintings by text by

KATHY OSBORN JACQUELINE CAREY

CHRONICLE BOOKS

SAN FRANCISCO

TO ALEX AND FRANK
– *Kathy Osborn*

TO CORA
– *Jacqueline Carey*

Printed in Hong Kong.

Library of Congress
Cataloging-in-Publication Data:
Osborn, Kathy
Wedding Pictures: a novel/paintings by
Kathy Osborn; text by Jacqueline Carey.
160 p. 17.8 x 20.3 cm.
ISBN 0-8118-1109-3 (hc)
I. Carey, Jacqueline. II. Title.
PN6727.077W43 1997
813'.54–dc20 96-33988 CIP

Book and cover design
VSA Partners, Inc.
Chicago, IL

Cover illustration
Kathy Osborn

Distributed in Canada by
RAINCOAST BOOKS
8680 Cambie Street
Vancouver, B.C.
V6P 6M9

10 9 8 7 6 5 4 3 2 1

CHRONICLE BOOKS
85 Second Street
San Francisco, CA 94105

Web Site: www.chronbooks.com

KIP

I adore your sister. We had a great time when she was in New York.

BONNIE

You know, it's funny. She said you wanted to marry me.

KIP

Well, I also told her I wanted to move to Italy.

BONNIE

Yeah?

KIP

And Italy's a little far, really, when you think about it.

BONNIE

I see.

KIP

You act like you're . . . surprised.

BONNIE

On the contrary. I know exactly where Italy is. I've been there. I even took a non-stop flight.

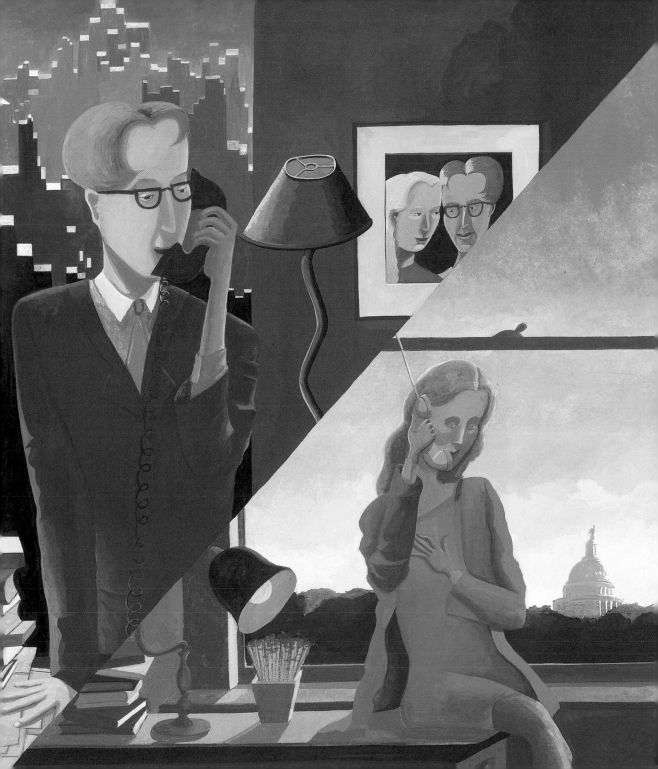

KIP

It's not like you've never gotten a proposal
of marriage.

BONNIE

Let me think. From Ethan? No. David? No.
Mark? Barry? Greg? No, no, no.

KIP

I asked you to marry me our first morning
together, in the hardware store.

BONNIE

That doesn't count. It wasn't clear whether you
were talking to me or the clerk.

KIP

Bonnie, my love, you and no other, will you
marry me?

BONNIE

Of course I will. See how much more effective
the direct approach is?

* * *

JULIE

Can I be the flower girl?

BONNIE

Of course you can. You're my favorite niece, aren't you?

JULIE

But you don't have any other nieces.

BONNIE

You're too smart for me.

JULIE

Am I going to wear a big white dress, like you?

BONNIE

It can go all the way from your shoulders to your toes, if you like.

JULIE

Are you going to have any maids?

BONNIE

Bridesmaids? Of course. I'm going to have bridesmaids and a wedding veil and a handsome groom. And I'm going to live happily ever after.

TANSY

I think your aunt has stars in her eyes.

JULIE

Yes. I see one.

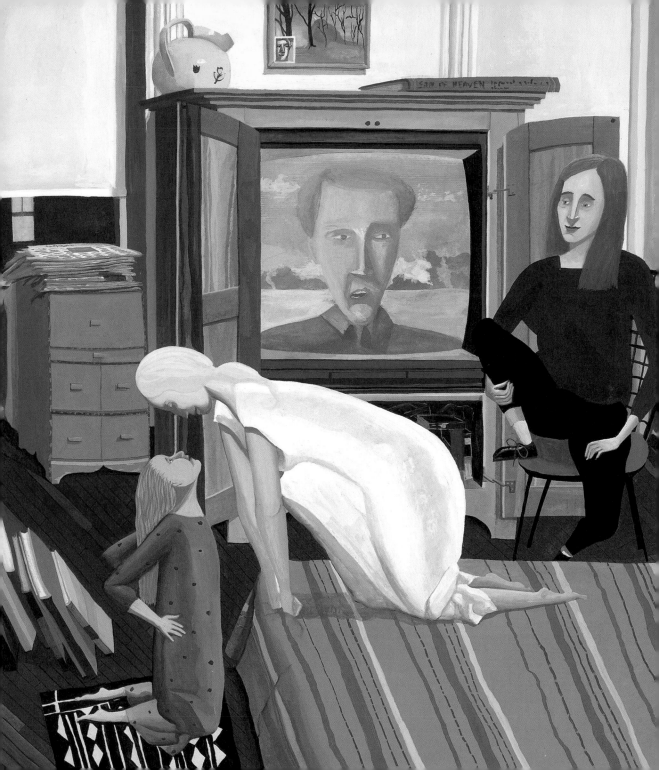

BONNIE

You sound like you don't approve.

TANSY

Not at all. I love Kip. He's an incredibly nice
guy. Too nice, if anything. But you've never
even lived in the same city with him, much less
the same, you know, few rooms.

BONNIE

It's not like we haven't seen a lot of each other.
I know him through and through.

TANSY

Most people like a little practice first.

BONNIE

I know you and Walter lived together before
you were married—

TANSY

Maybe. But that's no reason to dismiss
the custom.

BONNIE

You're not having trouble again, are you?

TANSY

No, no. That was a long time ago. But marriage
is so . . . oh, I don't know.

BONNIE

How can you say that? There are a lot of
happily married couples.

TANSY
Name one.

BONNIE
Well, the Lebhardts.

TANSY
The Lebhardts! Those zombies who live across from Kip?

BONNIE
They're not so bad.

TANSY
You're going to move in there and all be happy zombies together?

BONNIE
No, no. I suspect that Kip will end up moving here.

TANSY
You suspect?

BONNIE
We haven't made any decisions.

TANSY
But doesn't he try to get people to move to New York all day?

BONNIE
Not people. Companies. But that's just his job.

* * *

WALTER
In the movies, they're always doing it on desks.
Did you ever do it on a desk?

TANSY
No.

WALTER
See. I think it's unrealistic.

TANSY
But there was this dining room table . . .

WALTER
You did it on a dining room table? Really?

TANSY
Well, it wasn't set or anything.

WALTER
Huh. How about in a cab?

TANSY
God, no.

WALTER
In any moving vehicle?

TANSY
Probably. I can't think. How about the time
we took the train to Vancouver?

WALTER
Oh, right.

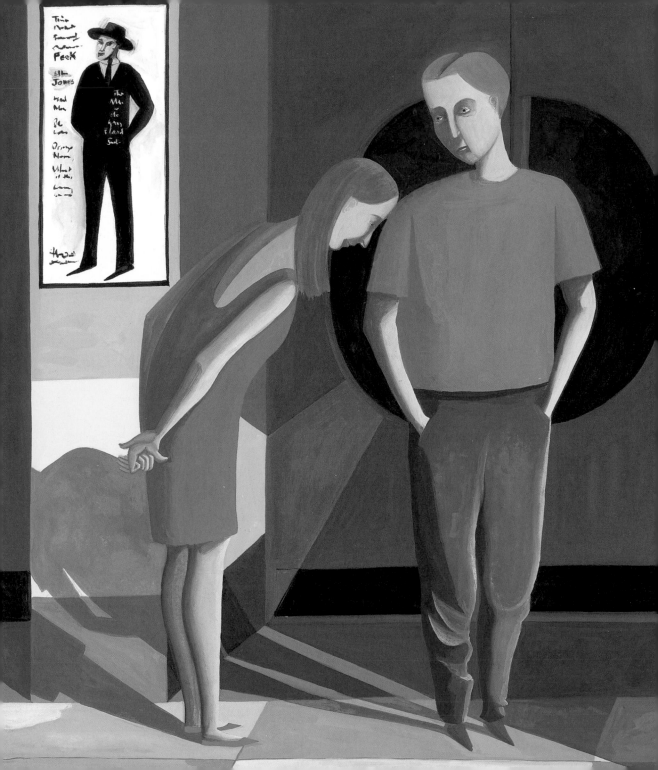

TANSY
And in parked cars, naturally.

WALTER
Naturally. In an elevator?

TANSY
No.

WALTER
Outside? Yes, of course. On a fire escape?

TANSY
Come on.

WALTER
Just answer yes or no.

TANSY
No.

WALTER
In an attic?

TANSY
No.

WALTER
On a boat?

TANSY
Yes. Two different kinds of boats, actually.
No, three.

WALTER
In the sun belt?

TANSY
Yes.

WALTER
In Culpeper, Virginia?

TANSY
Where's that?

WALTER
I was sick there once.

TANSY
How are you feeling now?

WALTER
I'm not sure. All right, I guess. But I'm not sure.

*　*　*

BONNIE I called the weather number in New York today.

KIP Oh?

BONNIE I knew you were out, and I wanted to see what it was like.

KIP It was raining.

BONNIE I know. And 45 degrees.

KIP That cold, eh?

BONNIE Mmm. It sounds wonderful.

KIP Wonderful? What's it like there?

BONNIE Sixty-five. Lonely.

KIP I see what you mean.

BONNIE Weather is so . . . personal.

KIP Whenever I walk down a street, I imagine what you would think of it.

BONNIE Oh, Kip.

KIP I just discovered the best place for coffee. We can go there every day.

BONNIE Every day? For some reason I thought we'd live here.

KIP Whichever. Either way is fine.

BONNIE But we have to make a choice.

KIP No problem. I'll move there.

BONNIE I'd hate to transfer to the New York office, that's all. It's such a dead end.

KIP Then don't.

BONNIE I could put out feelers for a new job.

KIP No. I won't let you. I'm going to start calling the weather number in D.C. every morning.

BONNIE I don't see why people have such trouble in their marriages, I really don't.

GEORGE
I told my wife I was meeting a client again.
Sometimes I scare myself when I hear the lies
that come out of my mouth.

FAY
I know what you mean. It breaks my heart
when I tell Billy I'll be late on the set. He looks
up at me with those trusting eyes. I can't bear it.

GEORGE
My brother is finally marrying Bonnie, you
know. When he told me, I thought—I was
innocent once.

FAY
They should hold on to what they've got! After
a while you can't tell what's true and what's not.

GEORGE
Perhaps if we'd never met . . .

FAY
What would it matter? I'm a terrible person.

GEORGE
Oh, no.

FAY
Do you think I was always terrible, deep down?

GEORGE
You were so good. I destroyed that.

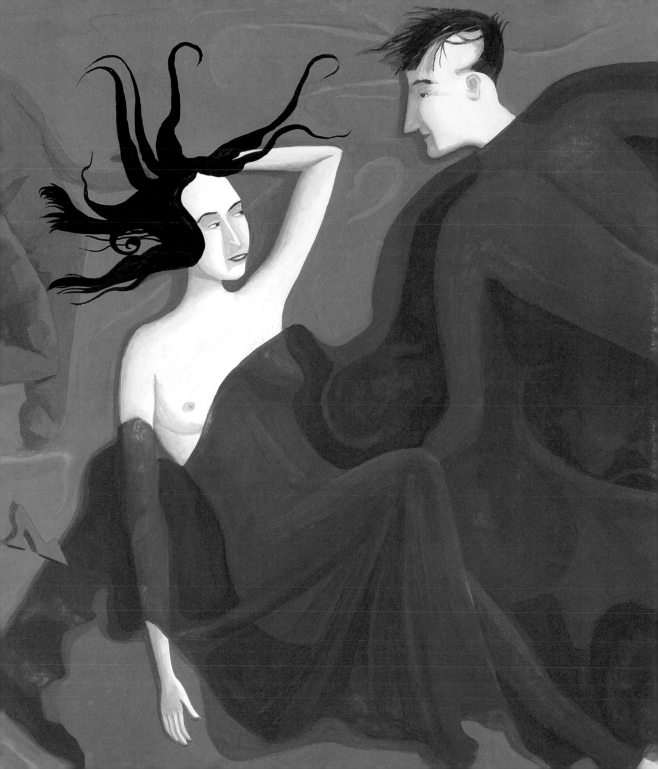

FAY
Billy and I had a sweet romance. We would
hold hands.

GEORGE
Your hands are so lovely.

FAY
I can't turn my back on the girl I was! I can't!

GEORGE
Oh . . . please . . . put your shoes back on.
Those are the sexiest shoes I've ever seen.

FAY
You like this?

GEORGE
Yes, yes.

FAY
Everything good in me is invested in Billy,
I know.

GEORGE
I'm slime. Slime! No woman deserves me.

FAY
Do that again.

GEORGE
I can't stand . . . I can't stand all this
sneaking around.

FAY
I know.

GEORGE
You haven't told anyone, have you?

FAY
I would die first.

GEORGE
I don't see how we can continue.

FAY
I don't—

GEORGE
A-a-ah.

* * *

GEORGE
You won't believe this, but it's close to eight.

FAY
Eight! There's no way I can make that drive in less than an hour. Where's my purse? You get the bill, and I'll get it next week.

* * *

HELEN
I don't understand why Bonnie won't let us
pay for the wedding.

TED
We're not paying? Don't bet on it.

HELEN
That's what she says.

TED
No one turns down free money.

HELEN
Free?

TED
With no strings attached, I mean.

HELEN
We would never expect anything in return!
We're her parents.

TED
I'm sure she didn't realize how hurt you'd be.

HELEN
We paid for Tansy's wedding.

TED
Down to those viewing contraptions that Tansy
insisted on handing out to all the guests.

HELEN
Oh, yes. I'd forgotten that.

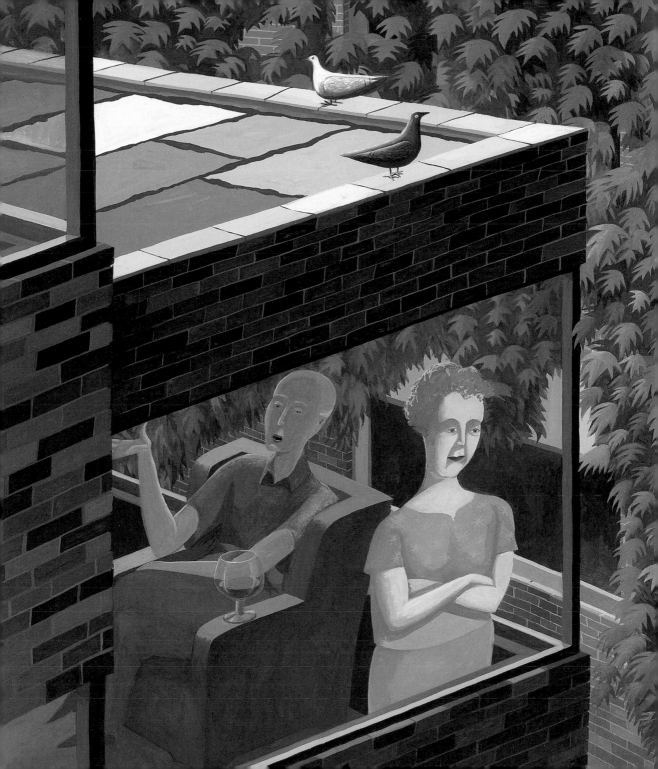

TED
Why everyone had to go up on a mountain and
watch the eclipse, I will never know. I'm only
sorry you were so taken up with the prepara-
tions that you wouldn't be firmer with her.

HELEN
I was the one who managed to talk her out
of having it above the timberline.

TED
Great. So we hiked one mile instead of two.

HELEN
That bar wasn't twenty yards off the road.
Besides, Bonnie is so much more sensible
than Tansy.

TED
I used to think so. Until she got that job.

HELEN
Remember how Tansy had planned to spend all
the money on the band and none on the food?

TED
But you weren't the one who changed her mind.
Oh, no, everything was all right with you. So I
had my little talk with Walter, and everything
was solved.

HELEN
Isn't that just like a man! You have a five-
minute talk with a guy, and you think you've
saved the world. Do you know how long it
took me to work out an all-vegetarian diet
with the caterer?

TED
Yes, those poached carrot sticks were a
real treat.

HELEN
Marguerite Vollman herself told me the
cous-cous was superb.

TED
Marguerite Vollman was certainly feeling
no pain.

HELEN
Of course not. Everyone had a great time.

TED
So?

HELEN
So I just don't understand why Bonnie won't
let us pay.

* * *

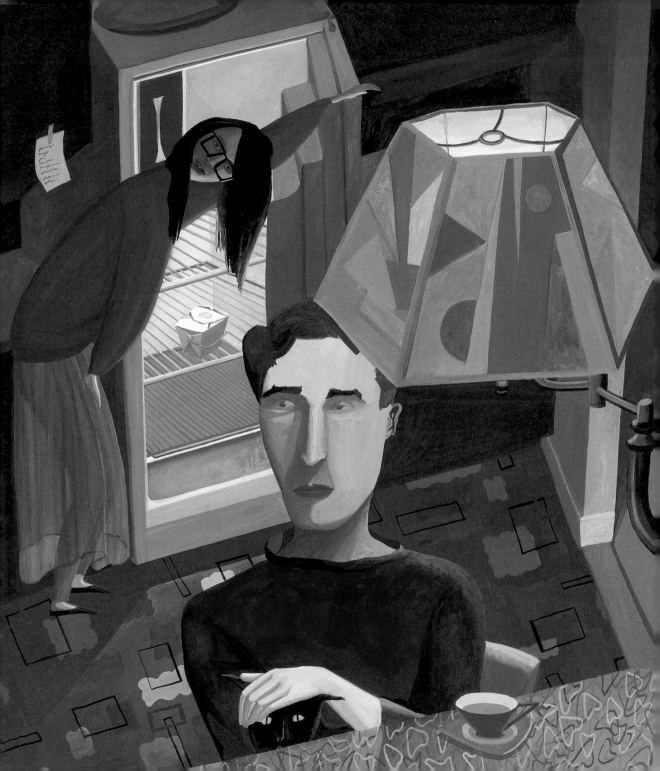

N° 6

FAY
I'm sorry I'm late.

BILLY
I got take-out. There's some tekka-don in the
refrigerator.

FAY
I had no idea of the time, or I would have called.

BILLY
You're always so scatter-brained. Did you lose
the watch I got you?

FAY
I don't know.

BILLY
I'll get you another. Please try to hang on to
it this time.

FAY
You're too good to me.

BILLY
Oh, I love to take care of you. And someone's
got to do it.

FAY
There was a lot more mail than we expected
on the "Women in Uniform" segment.

BILLY
That's all right.

FAY
It got later and later. You know how it is.

BILLY
Yes.

FAY
But I should have at least called.

BILLY
Well, it would have been nice.

FAY
I know it looks like I don't think of your feelings
any more. But it's not true.

BILLY
Of course I was worried.

FAY
I knew you would be.

BILLY
If you knew I would be, then why didn't
you call?

FAY
I don't know.

BILLY
You mean you deliberately didn't call?

FAY
Oh, I don't remember now.

BILLY

You better be careful, Fay. The whole show is riding on your shoulders. And you can bluff competence, but you can't bluff sweetness.

FAY

You think I'm not sweet any more?

BILLY

You're not being very sweet now.

FAY

I am! I'm being extremely sweet!

BILLY

Have it your own way.

FAY

No one could go through what I did today and come back all sweetness and light.

BILLY

You see. You're too smart not to know what's happening to you.

FAY

But I'm being sweet anyway! I'm being sweet as pie!

* * *

GEORGE

I'm sorry I'm late. A lobbyist's work is
never done.

LORRAINE

It doesn't matter. Bonnie was late, too.

BONNIE

Yes, I'm sorry. There was some sort of endless
motorcade on the Hill.

LORRAINE

Did you see it, George?

GEORGE

I must have missed that one.

LORRAINE

It was on Constitution Avenue, right near
your office.

GEORGE

What does it matter now? Bonnie and I may
be feeling guilty, but there will be plenty more
dinners in the future. I imagine she'll be my
sister-in-law for quite a while.

BONNIE

It was nice of you two to have me over.

GEORGE

But it's a special occasion! It's not every day my
little brother decides to get married. Unlike me.

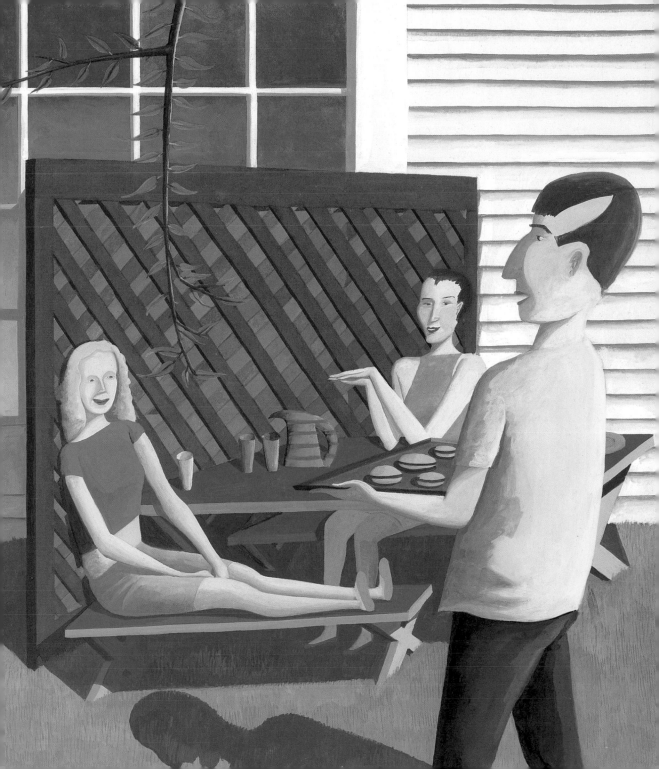

LORRAINE
I left work early to start the fire.

BONNIE
Oh, dear.

LORRAINE
You don't like barbecue?

BONNIE
No, no. I love it. It's my favorite food. I just . . .
didn't want you to go to any trouble.

GEORGE
So when are you going to do the dirty deed?

BONNIE
Soon, I hope.

LORRAINE
Don't worry if you have lots of doubts before
your wedding.

BONNIE
I don't have any doubts, exactly.

LORRAINE
It's perfectly normal to.

BONNIE
I'm kind of looking forward to it, actually.

LORRAINE
I'm sure you are. But I always wonder about
a person who doesn't admit to doubts. I think,
what could he be hiding?

BONNIE
Oh, I have doubts about everything. It's embarrassing. I still wonder things like, are you just a figment of my imagination?

LORRAINE
Why would I be a figment of your imagination?

BONNIE
You know what I mean. Or like, is the whole world just a scientific experiment?

LORRAINE
Well, it's not.

BONNIE
I know, I know.

LORRAINE
You must get that from your sister. She's some kind of scientist, isn't she?

BONNIE
Yes.

LORRAINE
You two are so different from your jobs. She's so emotional, and you're so . . .

BONNIE
I'm so what?

LORRAINE
So respectable-looking.

GEORGE
But fun-loving. Very fun-loving.

LORRAINE
You probably won't believe this, but before my wedding, George's first three marriages made me a little uneasy.

GEORGE
Now she tells me.

LORRAINE
They were very . . . short.

GEORGE
I made a couple of mistakes, that's all.

LORRAINE
And there's always something about the other person that will drive you absolutely mad.

GEORGE
Like what?

LORRAINE
George cracks his knuckles, for instance. I tell him it will give him fat joints, but does he listen? No.

GEORGE
That's an old wives' tale.

BONNIE
I don't think Kip has ever cracked his knuckles.

LORRAINE
You'd be lucky if that were all. It's a
minor problem.

BONNIE
I don't really have any problems with Kip.

LORRAINE
None?

BONNIE
I guess I can get bored by the fifty-seventh
hockey game.

LORRAINE
That's nothing. You call that a problem?

BONNIE
Well, no.

LORRAINE
I never complain about sports. Ever. That's one
thing you'll learn when you've been married
a while.

BONNIE
Oh.

LORRAINE
But don't worry. You'll pick it up soon, I
guarantee. And we'll keep your complaints
to ourselves, won't we, George?

* * *

TANSY
Bonnie says she and Kip have never fought.

WALTER
That's nice.

TANSY
How can you say that? They must have all sorts
of resentments simmering under the surface,
ready to erupt at any moment.

WALTER
Maybe they don't disagree about anything.

TANSY
Don't be ridiculous.

WALTER
What are you looking for?

TANSY
Now I can't remember . . . Bonnie didn't have
any trouble expressing her feelings as a child.
Once she kicked me so hard she broke a toe.

WALTER
I never used to fight.

TANSY
I know. At least I got you out of that stage.
What happened to the silly book on wedding
etiquette that your mother gave me?

WALTER
I still hate to fight.

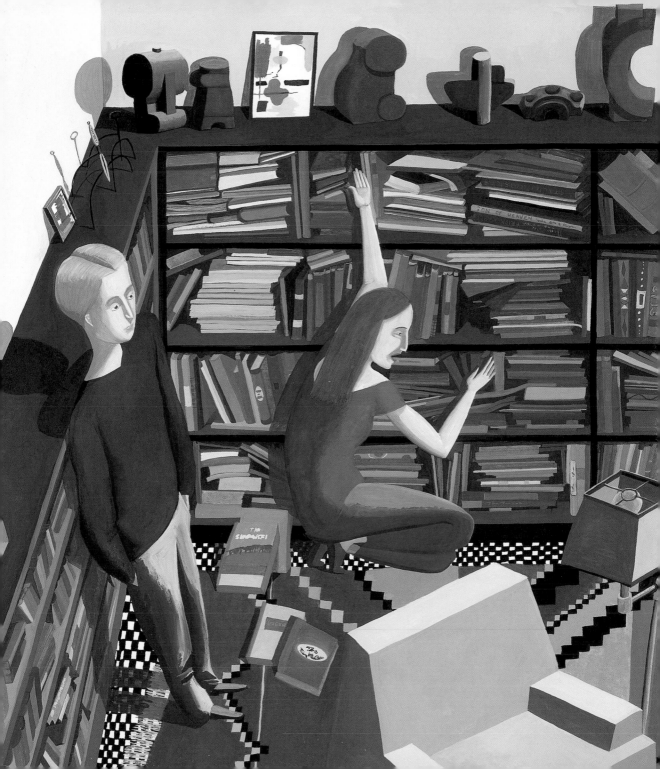

TANSY
That's hardly something to be proud of.
A good fight can clear the air. It can leave
you exhilarated.

WALTER
But I'm happy without fighting. I don't want
to fight.

TANSY
Then don't.

WALTER
But you're always making me. You're always
making me have feelings I don't feel.

TANSY
Like when?

WALTER
Like all the time. Like yesterday. You just kept
at me and at me until finally I had to tell you I
didn't like your dumb shrimp salad.

TANSY
You didn't seem to mind making up. We had
quite a nice time, as I recall.

WALTER
But I didn't care about the shrimp salad. At all.

TANSY
You could have fooled me.

WALTER
No, no. You don't get it. I like peace and
quiet. If I'm left alone, I have no feelings at all.
I just sit.

TANSY
No feelings?

WALTER
None.

TANSY
I suppose you had no feelings when we sat by
the lake in Glacier?

WALTER
No.

TANSY
Walter! How could you? That was one of the
happiest moments of my life!

WALTER
I love being repressed! There's nothing wrong
with it!

TANSY
Well, you're the one who's screaming.

WALTER
So? I thought you were the one who always felt
better after a fight.

TANSY
Oh, go away and leave me alone.

* * *

BONNIE Tell me we'll never wind up like George and Lorraine.

KIP What have they done now?

BONNIE I'm never quite sure. But I've been thinking. Tansy may be right. I can't name a good marriage.

KIP How about the Lebhardts?

BONNIE They're comatose. You can't have marital difficulties if you're comatose.

KIP Your parents may have had a bad marriage, but mine didn't.

BONNIE How do you know? Your father died so long ago that your mother has been married to a shrine for years. And your brother!

KIP Well, he certainly likes it enough to keep trying.

BONNIE Someone ought to tell him you can just live together nowadays.

KIP That should be one advantage to finding younger and younger wives. He should at least be kept up to date.

BONNIE Tansy may be bored with her marriage sometimes, but George's marriages have been far too interesting.

KIP You're not having second thoughts, are you?

BONNIE No, no! I just wish I could think of someone else who'd done it successfully.

KIP How about that friend of yours with the cable TV show—Fay? She remained true to her high-school sweetheart even after she hit the big time.

BONNIE No one knew what she saw in him in high school, either.

KIP I was amazed at how sweet they were to each other.

BONNIE George asked me for her phone number a while back. Trying to peddle a little influence, I suppose.

KIP You would probably miss her and Tansy if you came to New York.

BONNIE I wish you would make up your mind.

KIP It's just that there's so much going on right now.

BONNIE Well, I refuse to transfer to the New York office. I can start looking around for something else.

KIP No, no.

BONNIE Are you sure?

KIP It's about time I was around to chaperone George.

BONNIE Maybe you can save the new marriage.

HELEN
Are you thinking about Bonnie?

TED
No.

HELEN
So what are you worrying about?

TED
I'm not worrying.

HELEN
Then why is your face drawn?

TED
I'm thinking, not worrying. I've been thinking
about the green scarf I gave you for your
birthday.

HELEN
Right. The scarf. I keep meaning to wear it,
but no occasion seems quite special enough.
It's so pretty.

TED
Oh, it's pretty all right. It's very pretty.
Have you washed it?

HELEN
You don't wash a silk scarf.

TED
Never?

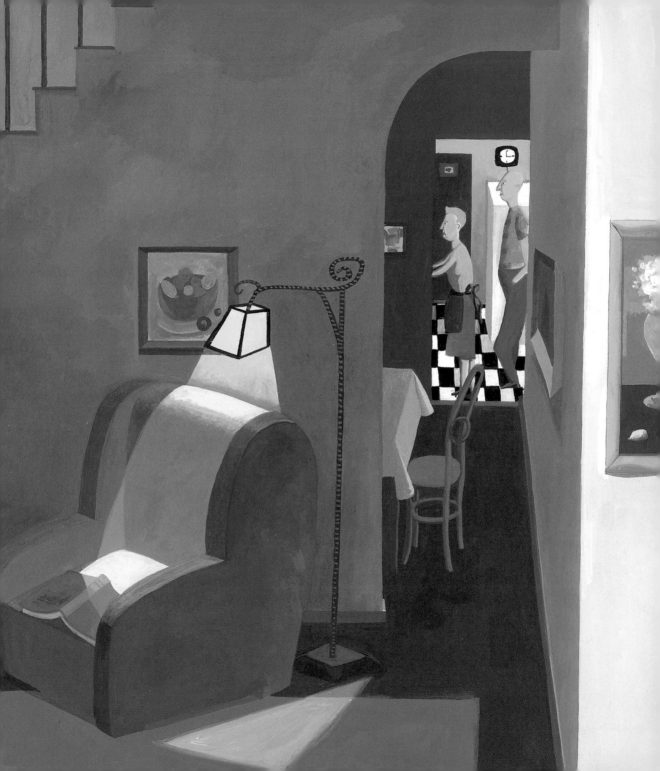

HELEN

Maybe you could dryclean it. But it's not dirty.
I've never actually put it on. We can have Kip
to dinner, and I'll wear it then.

TED

Kip seems like such a nice boy. I hope Bonnie
will be happy.

HELEN

Of course she will.

TED

There's no "of course" about it. You can't count
on anything in this world.

HELEN

Don't be such a sourpuss.

TED

You have to face reality. The social contract is
breaking down, and everyone is vulnerable.
This morning I had to break a safety seal off my
shaving cream. Shaving cream! See how far
we've come. Twenty-five years ago it didn't exist,
and now they're afraid it'll be tampered with.
It's almost criminal to leave a scarf just dangling
over a counter where anyone could get at it.

HELEN

What could happen to a scarf?

TED

There are a lot of crazy people out there.

HELEN

You think the scarf was sprinkled with cyanide
or something?

TED

The clerk was at the other side of the counter
when I came up, and it took me ten minutes
to get her attention. Anyone could have
come along.

HELEN

That's ridiculous.

TED

Take off your rose-colored glasses, my dear.

HELEN

A person doesn't wear a scarf in her mouth,
anyway.

TED

Awfully close.

HELEN

I don't even know how you think up these
things to worry about.

TED

You trust everyone, and you shouldn't. You
don't pay enough attention to what's going
on under your nose.

HELEN

I wasn't the one who forgot to pay the
electric bill.

TED

And don't think twice about money. That's the
last thing you should concern yourself with.
It was pretty expensive for a scarf, but it's still
just a scarf.

HELEN

Why, how much was it?

TED

Nothing is as important as a person's health.
When you've got it, you've got everything. I
didn't believe that when I was younger, but
now I know it's true.

HELEN

Listen, I'm sorry I never wore the scarf.

TED

No, no, thank God you didn't.

HELEN

I meant to. Really.

TED

I dread to think what might have happened.

HELEN

Maybe I could wear it to the rehearsal dinner.

TED

Just promise me not to touch it when I'm
not around.

HELEN

Maybe I could wear it to the *wedding*.

TED

How does the drycleaner's work? Do they
pick up?

* * *

KIP I suppose we could have a traveling marriage. At least for a while.

BONNIE We haven't been able to think of a successful marriage at all, let alone a traveling one. It would never work. I'd miss you far too much.

KIP I know what you mean. Oh, God, do you remember what fun we had the night the Lebhardts gave us a bottle of champagne?

BONNIE Don't remind me. It's torture.

KIP We've got only 97 days to go. I counted them up this morning at breakfast.

BONNIE Maybe we could settle down halfway in between. In Philadelphia somewhere.

KIP I doubt anyone in Philadelphia would hire me to lure businesses back to New York. But you at least could get a job. There must be pornographers everywhere.

BONNIE Pornographers?

KIP What's wrong? Am I supposed to call them artists now?

BONNIE I do not defend pornographers. I defend the First Amendment to the United States Constitution.

KIP I didn't know there was any gal/dog nudity in the First Amendment.

BONNIE I'm serious.

KIP Well, the Constitution is in force in all fifty states. To one extent or another.

BONNIE I'm getting a funny feeling from you. All of a sudden it sounds like you think your job is more important than mine, and that's why I'm the one who's supposed to move.

KIP I don't believe this.

BONNIE So tell me I'm wrong.

KIP It's not a question of importance.

BONNIE Then what is it a question of?

KIP I do happen to be at a very important juncture in my work, yes. And you can defend the Constitution just as easily in New York as in Washington.

BONNIE I knew it.

KIP But that's not fair. You make fun of your clients more than anyone.

BONNIE I don't make fun of them, exactly.

KIP Aren't you being just a little bit sensitive?

BONNIE That's such an old trick. Avoid the substance of the argument by subtly implying that a woman is too emotional. Prosecutors try to pull that one on me all the time. I'd thought you at least were above it.

KIP No one would dare accuse you of being too emotional. You're as stubborn as Plymouth Rock. You stand up in court with your earnest little suit and your pulled-back hair and your oh-so-serious manner and who could believe that what you're talking about is pornography? Maybe all those women with boots and whips are about to get dressed and go horseback riding.

BONNIE I'm speechless.

KIP I doubt that.

BONNIE No, I really am. I have nothing more to say to you.

KIP Don't you hang up on me! If you hang up, I'll never speak to you again!

BONNIE That's the point of hanging up. (Hangs up.)

BONNIE I just had a fight with Kip.

TANSY What did he say, the lying scum?

BONNIE Tansy!

TANSY Okay, what evidence did he give of temporary insanity, even though he is still basically a very lovable guy?

BONNIE I've never had a fight with him before.

TANSY You probably just needed the practice.

BONNIE No, no. Don't say that. It happened so fast. It was like one of those little brush fires that suddenly whoosh up and cover 200 acres and kill young children. It was awful.

TANSY A lot of screaming and crying?

BONNIE Not exactly. I hung up on him.

TANSY I always scream and cry. But I'm not sure I recommend it.

BONNIE He wants me to move to New York.

TANSY And you say he's not scum.

BONNIE He thinks I should be the one to move because my job is so ridiculous. He said I was being used to defend pornographers because I was a woman. He said I was . . . earnest.

TANSY He was never good enough for you.

BONNIE I can't bear it!

TANSY And his eyes are too close together.

BONNIE Do you think I should call him back?

TANSY Don't give him an inch.

BONNIE Maybe I should find out about getting a transfer. Because he's perfectly right. It would be much easier for me to switch cities than for him. Do you think I should call the New York office?

TANSY Absolutely not.

BONNIE It's still only five.

TANSY Don't do anything too quickly.

BONNIE Oh, Tansy, you're so right. I won't call him. I'll get myself transferred to the New York office and make it a big surprise.

KIP

I had a fight with Bonnie. I don't know
what to do.

MRS. LEBHARDT

I'm so glad you came to us.

KIP

It's our first fight.

MRS. LEBHARDT

Ah. Relationships take time to work themselves
out, you know. We've developed a number of
strategies over the years.

MR. LEBHARDT

The most important is, Never go to bed angry.

KIP

It's a little late for that now.

MRS. LEBHARDT

Don't let resentments build up. Be open about
your feelings.

KIP

Well, we were very open.

MRS. LEBHARDT

It's often the small slights, day after day, that
eat away at a relationship. If something is
bothering you, by all means, speak up.

MR. LEBHARDT
Be respectful, though. Always listen to the other person's point of view.

KIP
But what do I do now? She hung up on me. Should I try to get her back on the phone and apologize? Should I send flowers?

MRS. LEBHARDT
Flowers are so important, I think. You have to be sure to hold on to that initial romance. Exchange trinkets. Write each other little love notes.

MR. LEBHARDT
Go out on dates! My wife and I still go out to dinner every Friday. A relationship needs every bit as much attention as your car.

KIP
You know I don't have a car.

MR. LEBHARDT
And don't let yourself go to seed. Men especially have a tendency in that direction. They think if they've got somebody, they've got them for good. But you must exercise! Eat right!

MRS. LEBHARDT
Find a shared interest. Develop a hobby.

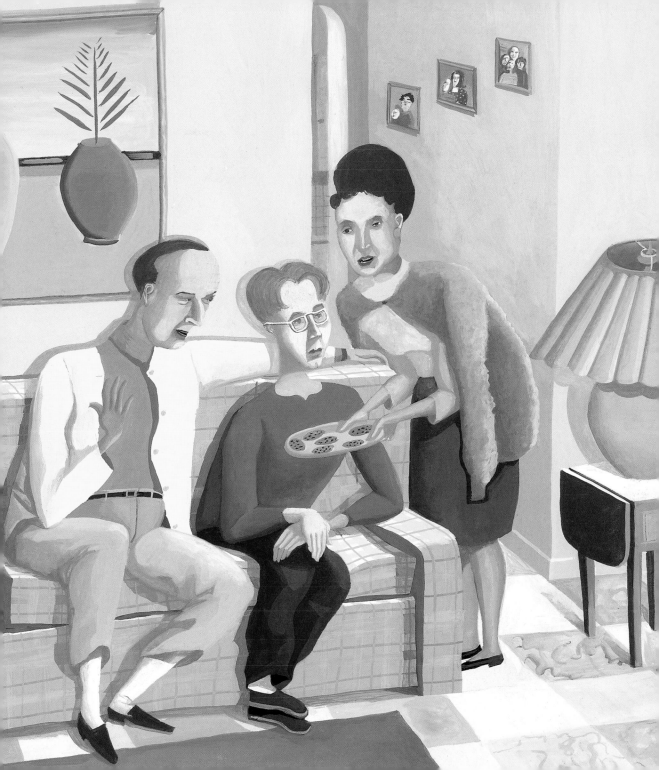

MR. LEBHARDT
Don't be afraid to compliment. You are not
ceding power. You are adding to it.

MRS. LEBHARDT
Think of the two of you as a unit, but don't
forget that each of you is an important part
of that unit.

MR. LEBHARDT
Give the other person some space.

MRS. LEBHARDT
Take a few minutes for yourself every day.

MR. LEBHARDT
Alternate holidays between families.

MRS. LEBHARDT
Always wear nice night clothes.

KIP
You know I don't have a car.

* * *

LORRAINE
I don't know why we have to live like this.

GEORGE
Like what?

LORRAINE
Every time I go to open the door to the bed-
room, the doorknob comes off in my hands.
Why can't we have a doorknob that works,
like normal people?

GEORGE
Look, I had a hard day. I'll fix it tomorrow.

LORRAINE
But you're always fixing it, and it never works.
Why don't you get a new one?

GEORGE
That is a new one.

LORRAINE
And you'll have a hard day tomorrow, too.
You always do.

GEORGE
Some people are just different from everyone
else. Some people don't have knobs that work.

LORRAINE
You're telling me that there have been broken
knobs in all your houses?

GEORGE
You know what I mean.

LORRAINE
No, I don't.

GEORGE
Why keep pretending?

LORRAINE
Pretending what?

GEORGE
Forget it.

LORRAINE
George, you're scaring me.

GEORGE
I . . . it's just a feeling I have. I can't put it
into words.

LORRAINE
But a doorknob is nothing, right? What does
it matter?

GEORGE
It doesn't matter.

LORRAINE
Then why are we talking like this?

GEORGE
I told you. It doesn't matter.

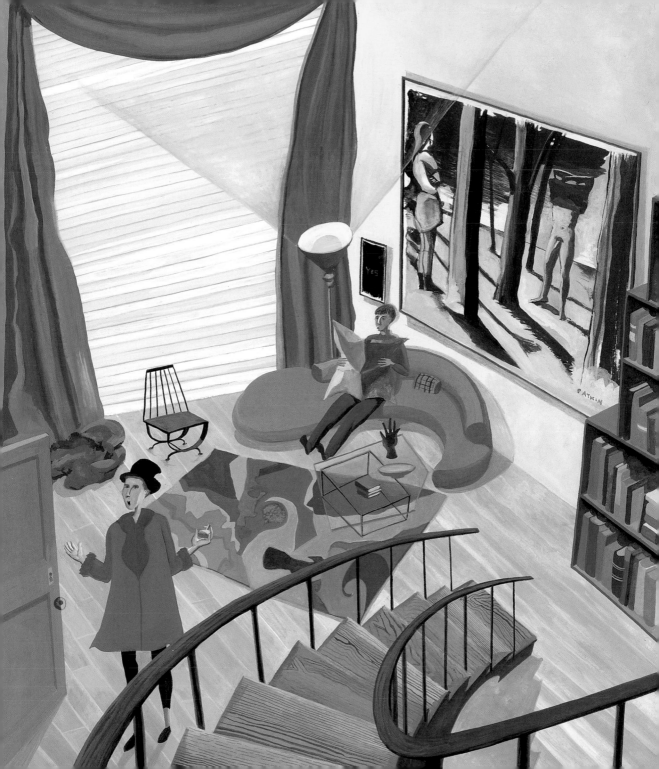

LORRAINE
I don't care about the doorknob, either.
Forget it.

GEORGE
It's forgotten.

LORRAINE
It was just something to say.

GEORGE
Okay.

LORRAINE
You know I love you very much.

GEORGE
I know, I know.

* * *

BONNIE Oh, Kip, I can't believe you're not there. And I can't believe I hung up on you. Wait. I started this all wrong. I'm still upset, and I can't even remember what we fought about. I don't care where we live. And if I had to choose between you and my job, I'd choose you any day. I didn't want to choose, though, and I figured that if you cared enough I wouldn't have to. Of course it's not that simple, but I got scared. Because I care so much. Please, please forgive me.

KIP I couldn't sleep last night. And now I don't even know where you are. Your secretary said you were out, so I can't picture you at your desk. I have this feeling that if I could just picture you, I would know you still loved me. I would know that the world had not turned upside down. Because how could everything change so fast? I was so happy, and I know you were, too. I couldn't have mistaken that. Do you remember that first night, when I was on the phone and you kissed me on the back of the neck? You started kissing everything, remember? You kissed the lamp and the desk and the papers, all because you were so happy. I'm sure I said all the wrong things yesterday, and now I'm afraid to say more, but I love you; I love everything about you, even your job. Especially your job.

BONNIE My heart leapt for joy when I heard your voice on my answering machine. I was happy, very happy, and I know I must still be happy, deep down, if I can respond that way to the simple sound of your voice. I'm in the lobby of the court building right now. I don't know if you can picture it, but you can picture me; I'm still the same, I assure you, and of course I love you.

KIP I was in conference when you called, but thank you, thank you for leaving a message. I feel a million times better. I suppose you're back in court now. You're right, I don't really know what it looks like. I have to rely on Perry Mason. In my mind, everything is sort of stagey and black-and-white, but you are there in the middle, still vibrantly my own darling Bonnie. Please forget all the stupid things I said. I'm going to work something out. Because I would rather live in Nebraska than lose you.

BONNIE Oh, Kip, my sweet. I wish you were there. I've been thinking madly and I have an idea. Do call me as soon as you can.

KIP Don't worry about anything. I've taken care of the whole problem. Talk to you soon.

KIP It's all set. I bought a car.

BONNIE A car? But you said you'd never have a car in Manhattan.

KIP I know.

BONNIE You mean . . .

KIP Bonnie, I'm so sorry. Forgive me. I'm a jerk. I've been working too hard, and it's fried my brain. But it's all set. I'm moving to Washington. You mean more to me than any silly job.

BONNIE You're so sweet. But you were right. I took care of everything. I'm moving to New York!

KIP No, no. I'm the one who's going to move. I just handed in my resignation.

BONNIE You're kidding.

KIP No.

BONNIE But I just handed in my resignation.

KIP You quit your job?

BONNIE I was going to transfer to the New York office, but at the last minute I couldn't do it. It's completely dead. I don't think anything is illegal there.

KIP Oh, Bonnie.

BONNIE I wanted a job at least as exciting as my new husband.

KIP You know I think you're a great lawyer.

BONNIE I know. But you're right about the suit. It's very earnest-looking. That's why I bought it.

KIP I love that suit.

BONNIE So just go and take back your resignation.

KIP But I can't. It's too late.

BONNIE Well, I can't take mine back.

KIP Oh.

BONNIE Why can't you take it back?

KIP My boss has been trying to get the job for his son-in-law for months. How about you?

BONNIE I may have said something about my boss's intense interest in the evidence.

KIP I don't believe it.

BONNIE So where should we live?

KIP Someplace cheap.

N° 12

GEORGE

I think Lorraine suspects something. She's been
acting really weird lately.

FAY

Oh, no. This is my worst nightmare.
What did she do?

GEORGE

Well . . . she keeps telling me she loves me.

FAY

So that is how low we have sunk. You think it's
weird when your wife tells you she loves you.

GEORGE

It shows she's nervous. Women only say it so
you'll say the same thing back to them.

FAY

I see.

GEORGE

Fay, look at me.

FAY

I can't!

GEORGE

But why? Here, give me your hand.

FAY

No, no.

GEORGE

Tell me what I said. I don't know what
I'm doing any more.

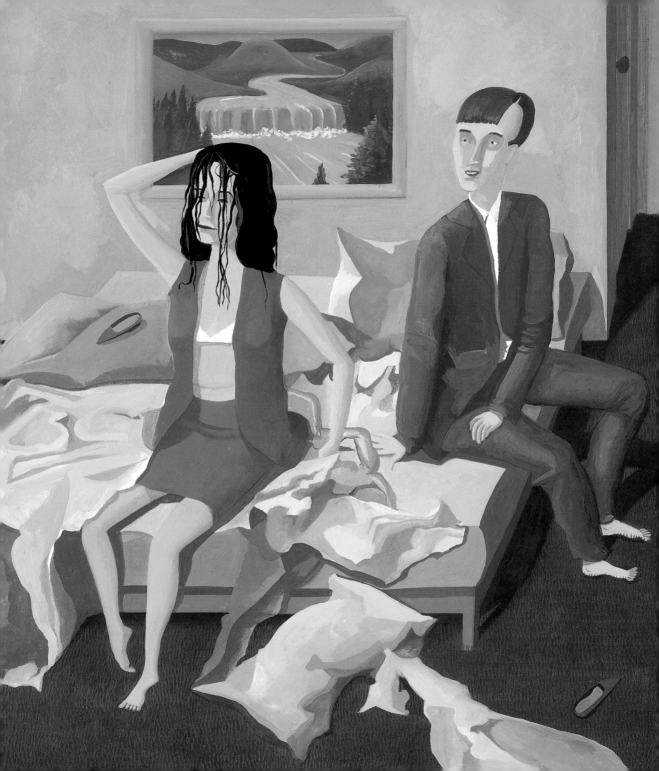

FAY
Look at how cynical we've become. Now
we'll never, ever be able to say "I love you"
to one another.

GEORGE
But, Fay, do you? Do you love me?

FAY
How can I think?

GEORGE
Maybe we should stop seeing each other.

FAY
Yes. I would never forgive myself if I destroyed
your marriage.

GEORGE
Oh, Fay, you haven't done it. I've done it. I'm
contemptible. I keep taking the wrong turn.
But how could I have acted differently?

FAY
I don't know. It's all so . . .

GEORGE
Kip's wedding is only a few weeks away. I won't
be able to keep my eyes off you. I can't keep my
hands off you now. I'm weak. Weak as water.

FAY
George . . .

GEORGE
Save me, Fay, save me! Oh, God, my
zipper's stuck.

* * *

N° 13

BONNIE
So I'm blissfully happy again. But now that
the marriage is on, the wedding is off.

TANSY
What are you talking about?

BONNIE
We certainly can't afford a big wedding with
both of us out of work.

TANSY
I'm sure the parents would pick up the tab.

BONNIE
. . .

TANSY
You're right. Forget the parents.

BONNIE
And who needs a big wedding, anyway? What
does it mean, other than a big headache . . . and
beautiful flowers and lovely music and people
I love all around me?

TANSY
Mmm.

BONNIE
At least I still have a groom.

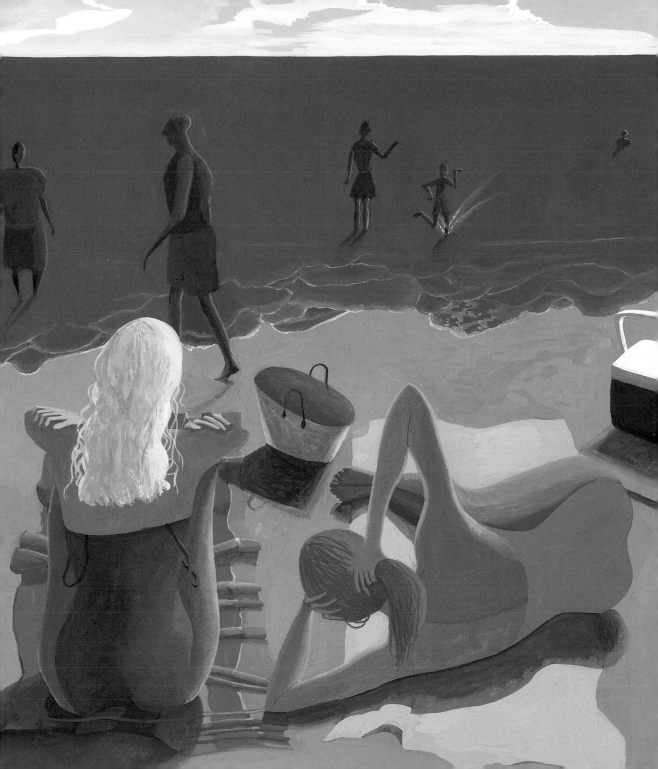

TANSY

A wedding doesn't have to cost a fortune. You can have a do-it-yourself one.

BONNIE

I suppose I'll have plenty of free time.

TANSY

What do you need, really?

BONNIE

A place, for one thing. If Kip had his way, we'd get married in Italy. He's always talking about it.

TANSY

I suppose a pizzeria wouldn't do.

BONNIE

Maybe a wedding-to-go.

TANSY

The trouble is, everything is so expensive. Even the bar where I had my wedding was pricey, and someone had shot the UPS guy in the parking lot the week before.

BONNIE

I can't have it at the parents'.

TANSY

But how about in a field or on a beach or something?

BONNIE

A field with lots of flowers! I love it!

TANSY
Of course it might rain.

BONNIE
Yeah. Besides, I don't know anyone with
a stray field.

TANSY
I think Walter still has the dance tape from the
Fifth Annual Go-Go-Galaxies Convention. Of
course, all the songs have to do with astronomy.

BONNIE
But I love that tape! Blue Moon! Ziggy
Stardust! Full Moon Full of Love! The Stars
Fell on Alabama!

TANSY
I don't know why people are always making
fun of scientists.

BONNIE
They have all the best tapes.

TANSY
Now if only we can get someone to run a few
tests on different kinds of hors d'oeuvres.

BONNIE
Or champagnes.

TANSY
But flowers! What am I thinking of? I am
intimately acquainted with a place that has a
lot of flowers . . . the Fargate Foundation.

BONNIE
You mean your lab?

TANSY
Think about how big some of the
greenhouses are.

BONNIE
But those plants are all, you know,
experimented with.

TANSY
Those flowers are lovely.

BONNIE
I know, I know. But don't they have . . .
funguses?

TANSY
You don't have to use the pest control room.

BONNIE
I suppose it depends on who I end up inviting.

* * *

HELEN I will admit I'm a little puzzled by the guest list.

BONNIE It's always hard to decide who to include.

HELEN And you must be so busy, since you've decided to do everything yourself.

BONNIE Oh, it hasn't been that bad.

HELEN Bonnie, you don't have to put up a front for me. I can tell how distracted you've been. You forgot Marguerite Vollman.

BONNIE Marguerite Vollman? Why should I invite her?

HELEN I can't believe my ears.

BONNIE I can't invite everyone I've ever met.

HELEN But Marguerite Vollman was so nice about getting you into skating class. I'd think you'd feel some gratitude.

BONNIE Mother, that was thirty years ago.

HELEN Twenty, maybe. But what is twenty years when you've lived as long as your father and I have? She always asks about you.

BONNIE By name?

HELEN Of course by name! She always mentions that little red beret you wore when you were on the ice. Besides, she won't think it at all odd that you're having your wedding in an experimental greenhouse. You know how much she loves flowers.

BONNIE I can think of no reason why I would know anything about her attitude toward flowers.

HELEN You must know that her house is on the Garden Club tour every spring. Even the year her husband was so sick.

BONNIE Oh, right. Isn't she the one who told you about the surprise party Daddy was giving you?

HELEN She did tell me ahead of time that she couldn't come. But I was grateful, in the end. And she was the reason I went on a diet. Surely that was a good idea.

BONNIE Okay, okay, I'll invite her. But it will triple the liquor bill.

HELEN What are you talking about? Marguerite Vollman doesn't have a drinking problem.

BONNIE Look, it doesn't matter to me whether she does or not.

HELEN And where did you get that, anyway? You don't know anything about her. You haven't seen her for years.

N° 14

BONNIE
Those are the bridesmaids' dresses?

FAY
Aren't they perfect? And The Five Flavors say
they absolutely don't need them back.

BONNIE
The Five Flavors? You mean the singing group?

FAY
Yup. Can you believe it?

BONNIE
Well, they certainly aren't ordinary
bridesmaids' dresses.

FAY
Of course you don't have ordinary bridesmaids.

BONNIE
No, I suppose not . . . You know, I wish some-
times I got married right out of high school,
the way you did. Before I took everything so
seriously.

FAY
You were always pretty serious.

BONNIE
No, I wasn't.

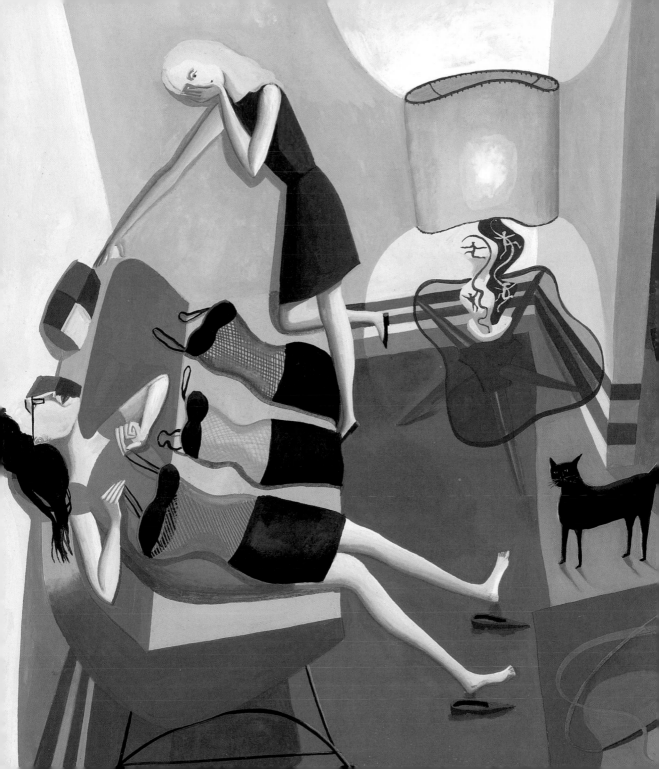

FAY
Don't you remember the afternoon we took
off with those bikers? You brought a book
with you.

BONNIE
And they both turned out to write very
bad poetry.

FAY
It was right before I decided to marry Billy.
God knows I was serious about him. He was
the love of my life, and there is still a side of me
that only he knows. I just hope that side doesn't
get too small.

BONNIE
You've certainly changed more than he has.

FAY
People always say that when they mean, "What
are you still doing with that jerk?"

BONNIE
I don't mean that.

FAY
We really are in tune with each other, you know.

BONNIE
It's funny, I haven't heard you speak so fondly
of him since you stopped sleeping with that
traveling salesman.

FAY

He was in promotion, not sales.

BONNIE

Wait a minute. You're not still sleeping with him, are you?

FAY

Well… with George, actually.

BONNIE

George? You mean Kip's *brother* George?

FAY

You've got to admit he's incredibly cute.

BONNIE

I can't even talk to him.

FAY

Maybe men are supposed to be weird about women. Maybe we're fooling ourselves, thinking they can be pals.

BONNIE

But Fay, you were miserable when you had that other affair.

FAY

I know.

BONNIE

And now you're having another one?

FAY
He's still a little boy. That's his appeal, I think.

BONNIE
You should figure out what you want.

FAY
I don't have time. Don't you see? I'm going to wake up tomorrow and I'll be eighty years old, and I won't have figured anything out yet. I've got to do something now.

BONNIE
Oh, God. This is too complicated for me.

FAY
Don't worry. I promise to behave at your wedding.

BONNIE
The wedding is going to be the simple part.

* * *

HELEN
Now this is what I call a wedding dress.

TED
A wedding dress. Yes.

HELEN
Would you call it "feminine" or "elegant?"

TED
Well, it certainly is for a female.

HELEN
No, no. There are four categories of wedding dresses. "Classic" and "offbeat" are the others, and if Bonnie weren't wearing Kip's mother's dress, I would worry, considering what some of her other choices have been.

TED
What are you talking about?

HELEN
I read an article in the paper last week that analyzes you according to what type of wedding you prefer. Believe me, it was not kind to young women who arrange everything themselves without consulting their parents.

TED
This was in the newspaper?

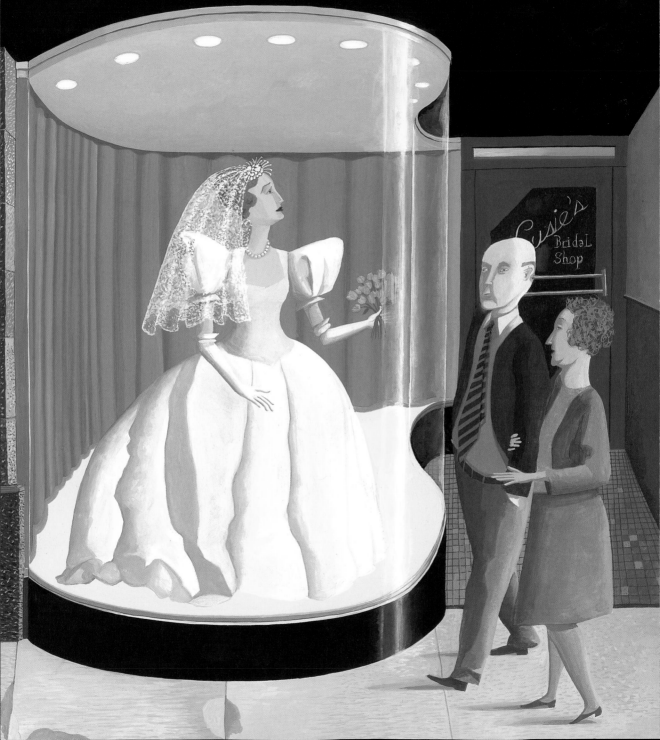

HELEN

Yes. It's amazing what they can do these days.
There was an analysis according to location,
too: whether it's in your hometown or where the
bride and groom live, or if it's something called a
"Destination Wedding." That's when everyone
has to travel somewhere that has nothing to do
with anything, like for Tansy's. It shows she has
firm ideas, and there's a danger she'll try to run
other people's lives. Now that is Tansy to a *T*.

TED

Does it say anything about a wedding that takes
place among mutant plants?

HELEN

Not exactly. But it said I was modest and
family-oriented. That's certainly true.

TED

What reveals your nutty interest in wedding
analysis?

HELEN

It said that marriage on a major holiday like
New Year's Eve could be the sign of a shaky
ego. At least you'd always have something to
do that night.

TED

I wouldn't say Bonnie had a shaky ego. Besides,
is she getting married on a holiday?

HELEN

No. That's when you wanted to get married.

TED

What?

HELEN
You wanted to get married on New Year's Eve.

TED
I did not.

HELEN
Maybe it was New Year's Day. That's probably
a little better.

TED
We got married on May 8th. That's not
even close.

HELEN
I can't believe you don't remember.

TED
And how about not wanting to get married at
all? What's that a sign of?

HELEN
I don't know why you're getting upset with me.

TED
I'm not getting upset.

HELEN
I didn't think the analysis up.

TED
I would never get upset about something
so foolish.

HELEN
It's a very scientific, objective study.

* * *

BONNIE

You won't believe it. Fay is having an affair
with George.

TANSY

What part am I not supposed to believe?

BONNIE

Tansy!

TANSY

Well, it will make for an interesting wedding
reception.

BONNIE

George should have put three people on top
of his cake.

TANSY

Maybe a whole crowd.

BONNIE

Do you think he'll introduce her to Lorraine?
Or pretend not to know her?

TANSY

And you didn't want to videotape your
reception.

BONNIE

I can stand the two of them side by side for the
pictures . . . but I still don't believe it.

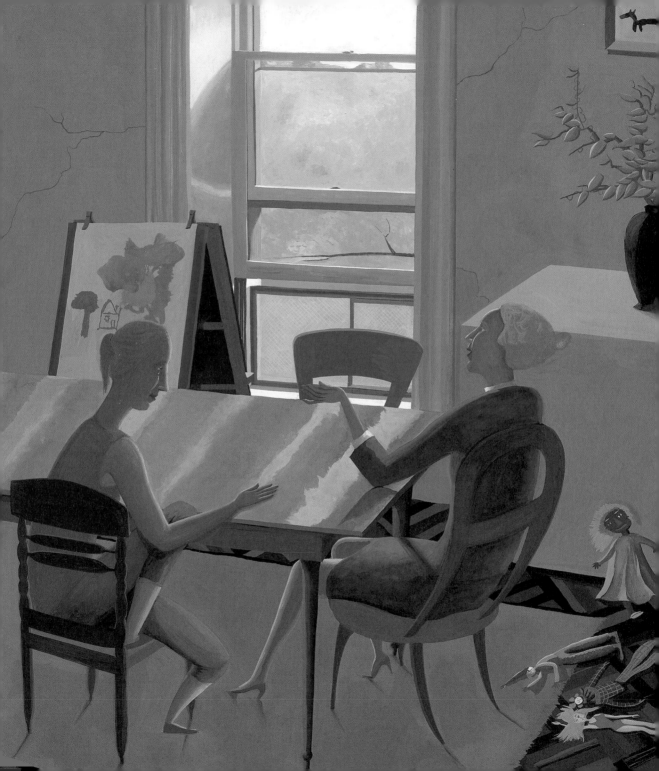

TANSY
People have affairs all the time.

BONNIE
That's not true. You don't.

TANSY
It's not because I haven't been tempted.

BONNIE
Oh, well, temptation. . . .

TANSY
But sometimes I think I should just go ahead.
There was this incredibly smart little guy in
Helsinki—

BONNIE
Helsinki? You mean just this past month?

TANSY
My last conference, whenever that was. We
were seated together at dinner, and we started
talking quite nicely—you know, how are you
and nice weather and what are you working
on and stuff like that—when suddenly we were
arguing about protein formation, and he was
swearing and I was swearing and we got closer
and closer and the whole thing got more intense
until I swear we might as well have been under
the table doing it right then and there.

BONNIE
Oh, Tansy.

TANSY
Sometimes I think I'd sleep with the first man
who asked me.

BONNIE
Even George?

TANSY
I'd sleep with George in a second.

BONNIE
But I thought you and Walter were getting
along so well these days.

TANSY
What does that have to do with anything?

* * *

GEORGE
I didn't expect it to be just the two of us.

KIP
No? Well, I wanted a little quiet before
the storm.

GEORGE
But a bachelor's party is usually—

KIP
You wanted something wilder? The cake will
roll in after a while.

GEORGE
Ha! Whatever you want is what I want.

KIP
This is what I want.

GEORGE
Good.

KIP
So when was the last time we had a
beer together?

GEORGE
I don't remember.

KIP
In June, I think.

GEORGE
Really?

KIP
Remember, you were talking to the waitress
about her shell earrings?

GEORGE
Look. I know Fay told Bonnie about us.

KIP
What?

GEORGE
Uh, oh.

KIP
What do you mean? You're having an affair
with *Fay?* Bonnie's friend Fay?

GEORGE
I know I should have told you . . .

KIP
I didn't even know you knew her.

GEORGE
. . . but it's not something I wanted to advertise.

KIP
I can't believe Bonnie didn't tell me.

GEORGE
It's just something I do.

KIP
You mean you've had a lot of affairs?

GEORGE
Well, yes.

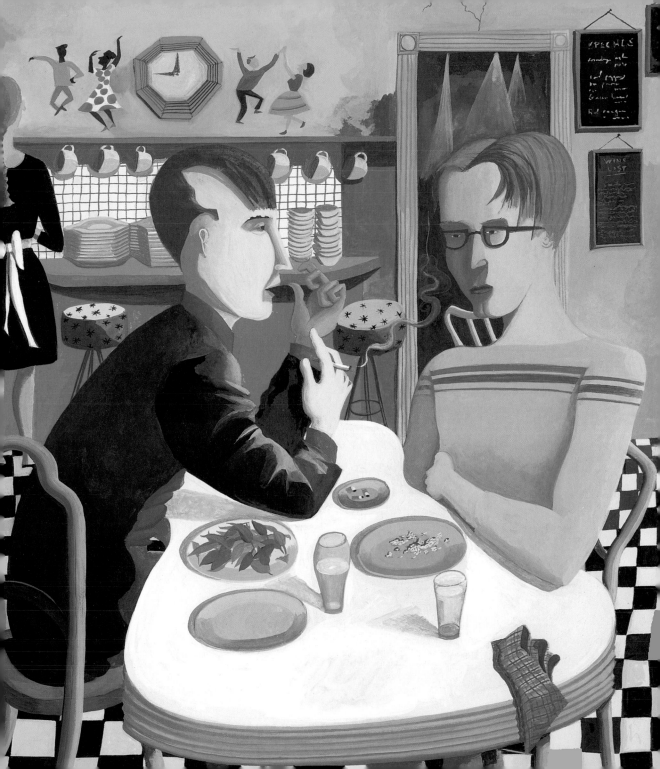

KIP

I can't believe I didn't know.

GEORGE

What you must think of me. . . .

KIP

But you keep getting married.

GEORGE

I know. I can't help it. Getting married is so exciting. But then I love to cheat. I do. I mean, I hate it, because I think I'm weak, but I love it because it's so exciting. And it makes the marriage better, too. Think of why a formal dinner party is so much fun. You get all dressed up, you look great, you take a long time eating a lot of silly little dishes. The whole point is the pretense. And see, that's what I do with marriage. By making it a lie I make it into art. Why consign marriage to real life?

KIP

I like real life.

GEORGE

Wait until you've been married a few years, and you know your wife so well that you can predict what she's going to say before she says it. You can have whole conversations without opening your mouth.

KIP

Clearly that's not going to happen with Bonnie. She never tells me anything.

* * *

BONNIE

I want to thank you for giving us this rehearsal dinner. Everything looks so lovely.

FRAN

You don't know what to call me yet, do you? It's hard to tell these days. *My* mother-in-law insisted I call her "Mother." It always made the word into a joke for me. Something about the formality, the inappropriateness. Like naming a dog Stalin.

BONNIE

Oh, well.

FRAN

Because she certainly wasn't my mother. Nothing like her.

BONNIE

Really?

FRAN

So call me Fran. Everybody else does.

BONNIE

Okay, Fran.

FRAN

Of course things were different back then. When I married my husband, it was for life. *My* life. The grave does not separate us.

BONNIE

I know.

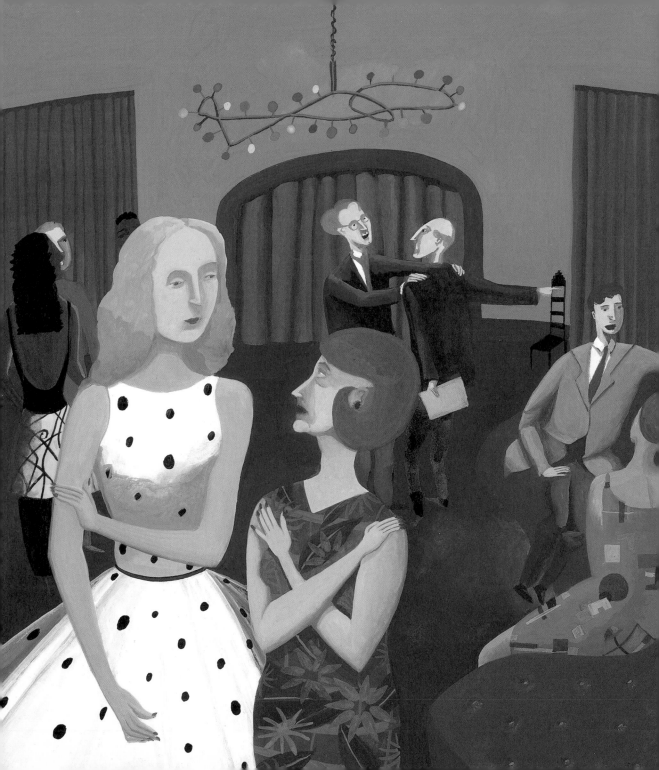

FRAN

None of this hopping around.

BONNIE

Well, I'm not going to hop.

FRAN

And while we're being frank with each other, I want you to know how happy I am that you're the one Kip decided to marry.

BONNIE

Hunh.

FRAN

Think about it. I can tell you're good at that. Kip is very happy-go-lucky. Talks to everyone. A real man's man. Look at him now. Big grin on his face. You'd think the maitre d' saved his life once, the way Kip is acting. His girlfriends were always the same way. Life of the party. Very beautiful, but a screw loose somewhere, maybe. Not real marriage material. Because Kip has a core. You know it, and I know it, but they didn't know it. You can't expect the sort of solid relationship Kip's father and I had if you marry a puffball. You need sincerity. You need depth. You need seriousness. Someone quiet and dependable, like you.

BONNIE

Well, thank you. But I'm not really all that quiet.

FRAN

Oh? Then how come you never say two words to me?

*　*　*

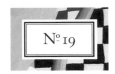

N° 19

BONNIE
So how many people in this room have you
slept with?

GEORGE
Just two.

BONNIE
Really?

GEORGE
Well, I tend not to sleep with relatives.

BONNIE
How very restrained of you.

GEORGE
I made out with my cousin Margot in fifth
grade, but we never made it past second base.

BONNIE
A baseball fan from way back, I see.

GEORGE
Come on, Bonnie. Don't be mad at me.

BONNIE
It's none of my business what you do with
your life.

GEORGE
Bonnie, Bonnie, you cut me to the quick.

BONNIE
Okay. I may be overreacting a bit.

GEORGE
I hope you and I are still friends.

BONNIE
Fay has a theory that men and women can't
be friends. Maybe she's right.

GEORGE
But Fay and I are dear, dear friends. I swear
to you.

BONNIE
Oh, George.

GEORGE
I have lots of women friends.

BONNIE
Friendship takes lots of time and attention.
You're not friends with people just because
you say you are.

GEORGE
It's a good start.

BONNIE
I could say that I'm friends with the President,
but that doesn't make it true.

GEORGE
I suppose that's a swipe at us lobbyists.

BONNIE
No, no.

GEORGE
Men are different from women. They don't
have to reinforce their friendships all the time.
Take Teeples. I never see him, and I consider
him one of my best friends.

BONNIE
Teeples?

GEORGE
We can take each other for granted
in the best sense.

BONNIE
You mean Mark Teeples?

GEORGE
Yeah.

BONNIE
He's coming tomorrow.

GEORGE
Really?

BONNIE
He goes out with someone at the firm.

GEORGE
I didn't know that.

BONNIE
What a sweet guy. But he's never even
mentioned your name.

* * *

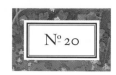
WALTER
I suddenly realized something.

TANSY
What?

WALTER
You like to eat more than you like to have
sex with me.

TANSY
How can you say that?

WALTER
You're making more little grunts of pleasure
now than you ever do when we're in bed.

TANSY
Hunh.

WALTER
See. There you go again.

TANSY
You know, Walter, I remember every single
crazy thing you ever said to me.

WALTER
I doubt it.

TANSY
Would you like some examples?

WALTER
You can't even remember to buy milk.

TANSY
I suppose you're talking about Wednesday
night.

WALTER
At least you remember that.

TANSY
We didn't need milk. I was harassing you.

WALTER
We didn't need milk?

TANSY
You were three hours late by then, and I was as
glacial as I could possibly be on the phone, but
you still didn't seem to realize how angry I was.
That's why I told you to stop and get the milk.

WALTER
But you made me even later.

TANSY
So?

* * *

N° 21

KIP
Why didn't you tell me George and Fay were
having an affair?

BONNIE
I assumed that Fay told me in confidence.

KIP
Bonnie! My own brother!

BONNIE
An affair is secret by its very nature.
Res ipsa loquitor.

KIP
But they both assumed you'd told me. Don't
you see, you're *supposed* to tell your mate
everything. There's a legal term for that, too.

BONNIE
Marital confidences are protected, not required.
Besides, you are such an open person, the news
is going to be all over your face at the wedding
tomorrow.

KIP
Can't you see why I'm afraid we still don't talk?
We're charging off in two different directions.
And you promised me you'd tell me everything.

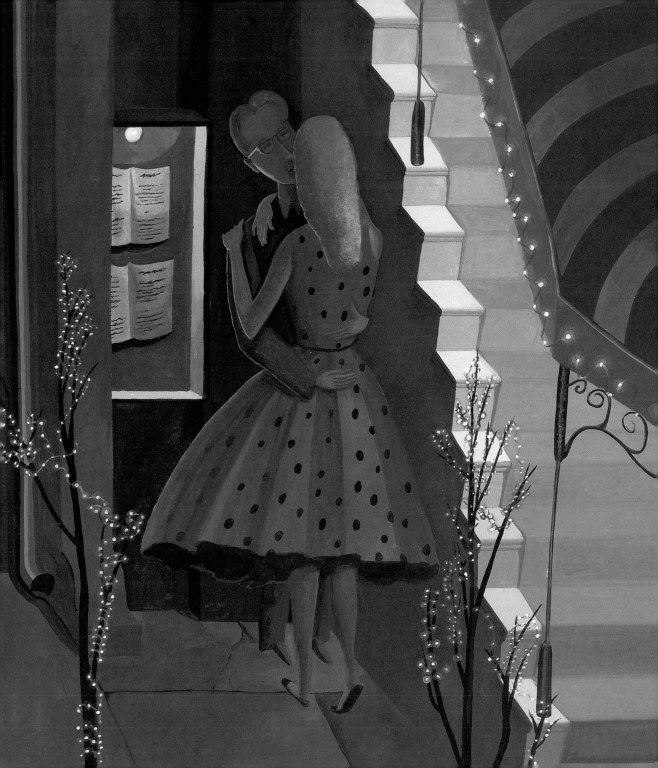

BONNIE
But then how can I surprise you?

KIP
I don't mean you have to tell me what my
Christmas present is at the same time you're
wrapping it.

BONNIE
All right. I will tell you that I have a surprise for
you tomorrow.

KIP
Me, too, actually. But I know you're going to
love it.

BONNIE
You're breaking off your affair with your
periodontist.

KIP
What!

BONNIE
I'm sorry. It just seems as if everyone has gone
nuts. Tansy said she'd sleep with the first person
who asked her.

KIP
Really?

BONNIE
It makes me think that's what marriage is
all about.

KIP
It can't be. Someone would have told us.

BONNIE
But that's just the point. Everyone has.

KIP
Look. We can have our own unique sort of
marriage. Neither one of us will have an affair.

BONNIE
Oh, Kip. What a wonderful idea.

* * *

BILLY

It's hard to drive with you beside me. I keep
wanting to look you rather than at the road.

FAY

Oh, Billy. You're so sweet to me.

BILLY

No, no. It's the truth. I was incredibly lucky
to meet you when I did. If we met now, you'd
never notice me. Not in a million years.

FAY

Don't be silly.

BILLY

We probably wouldn't even meet, though.
I wouldn't dare to talk to you.

FAY

Our eyes would lock across a crowded room.

BILLY

Ha!

FAY

And you would see the real me. The good me.

BILLY

I think it's awfully nice of you to be in
Bonnie's wedding.

FAY

I wouldn't miss it for anything.

BILLY

Not everyone would stay true to old friends
the way you have.

FAY

I'm still the same person, inside.

BILLY

Don't have more than one drink. You know
you have that publicity shoot in the morning.

FAY

Yes, yes.

BILLY

I'm perfectly serious. No one else at
the reception will have to look perfect in
the morning.

FAY

I know.

BILLY

Think of all the people counting on you.

FAY

You never let me forget.

BILLY

I'm just thinking of what's best for you.

FAY

I know.

BILLY

Remember that people expect you to be as nice
as you are on TV. They think that warm person
is you.

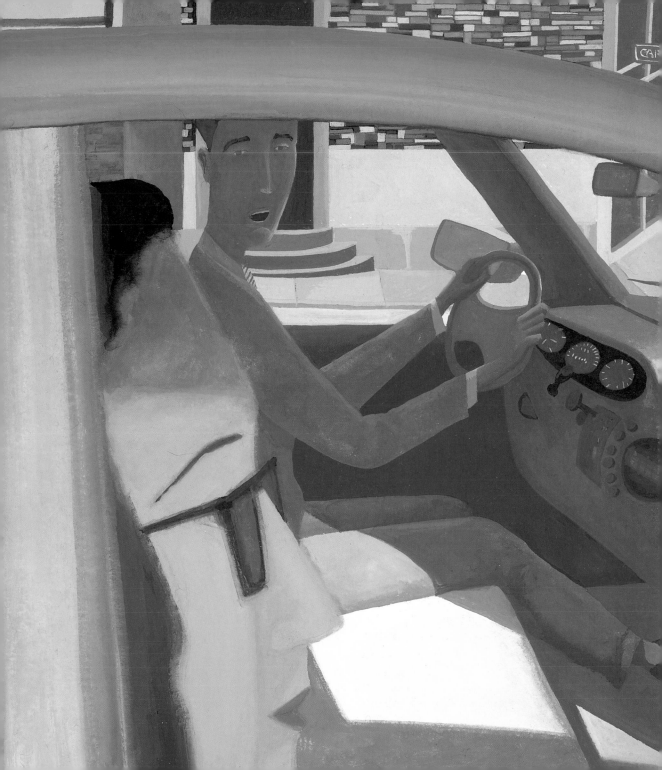

FAY
I know.

BILLY
And don't dance. It's not your strong suit.

FAY
You don't like the way I dance?

BILLY
I do, I do. It's just that people expect a
certain . . . people expect you to do things
better than everyone else.

FAY
You used to like to dance with me.

BILLY
Well, I didn't marry you for your sense of
rhythm.

FAY
My God, is that what people are saying
behind my back?

BILLY
People are saying they've never seen anyone
sweeter, or more beautiful, or more talented.

FAY
But my dancing. I had no idea. Why didn't
you tell me?

BILLY
I wouldn't hurt your feelings for all the world.

* * *

N.º 23

TANSY
Something old?

BONNIE
My hairdo.

TANSY
Bonnie, be serious. Your hair is lovely.
Very chic.

BONNIE
Okay, okay. The dress.

TANSY
Something new?

BONNIE
A job! I just found out. You know how Kip's
always going on about Italy? I got myself a job
there. Can you believe it?

TANSY
It's a good sign. But how will I live without you?

BONNIE
I'm going to have to carry a cellular phone with
me everywhere. But it won't be more than a
couple of years.

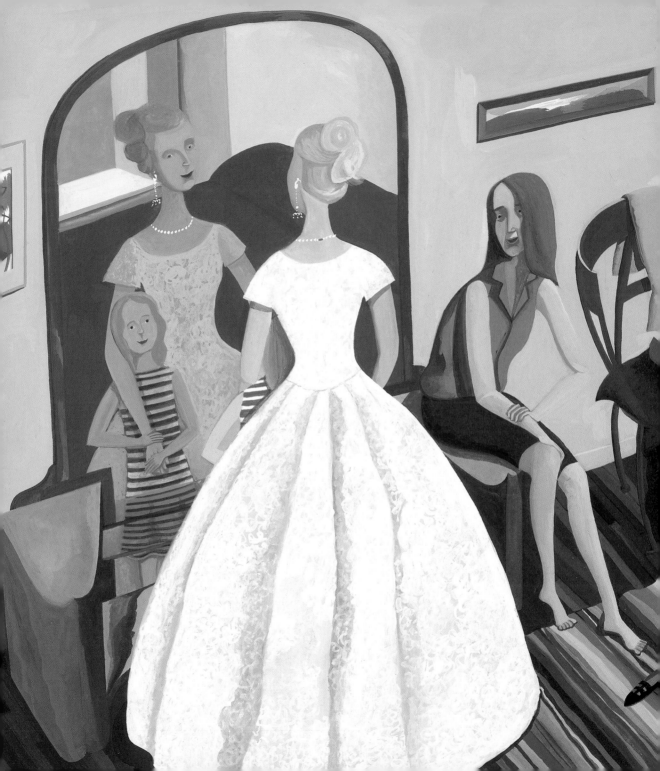

TANSY
It's amazing, the power of a marriage.

BONNIE
I wrapped a map of Italy to give to Kip as my
wedding gift.

TANSY
I don't think Walter gave me anything.

BONNIE
What did you give him?

TANSY
Well, I bought myself a lasagna pan.

BONNIE
I don't think that counts.

TANSY
He's the one who loves lasagna. But we had
a wonderful wedding, didn't we?

BONNIE
You really did.

TANSY
Walter was so gorgeous. He was wearing that
tie with Saturn on it.

BONNIE
Walter was always a real cutie.

TANSY
Do you think I like to quarrel?

BONNIE
Yes.

TANSY
But that's not true!

BONNIE
Ha!

TANSY
So. Something new. Job. Also, shoes. Something
borrowed?

BONNIE
Your earrings.

TANSY
Something blue?

BONNIE
I should carry the last issue of *Bondage* that
I'm ever going to have to defend. God.
Bondage. I wonder what that is in Italian.

TANSY
Amore.

* * *

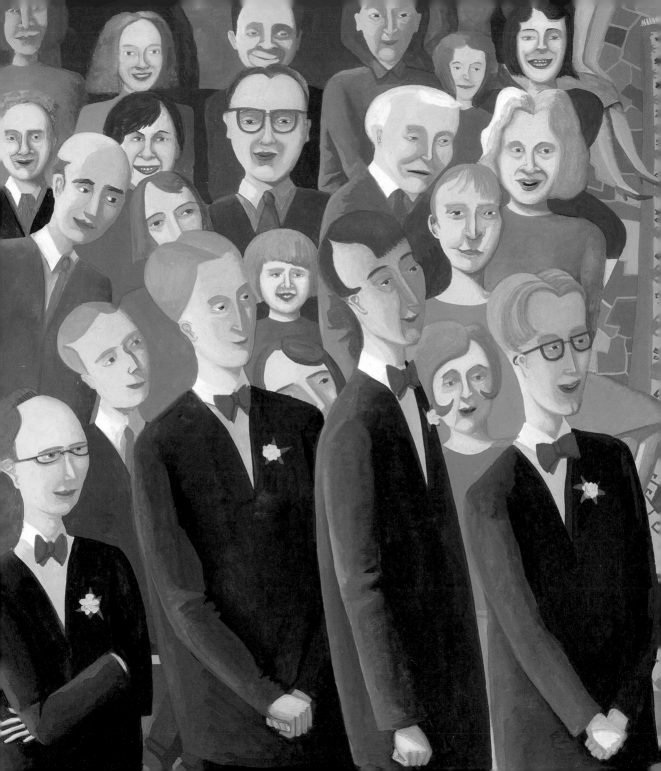

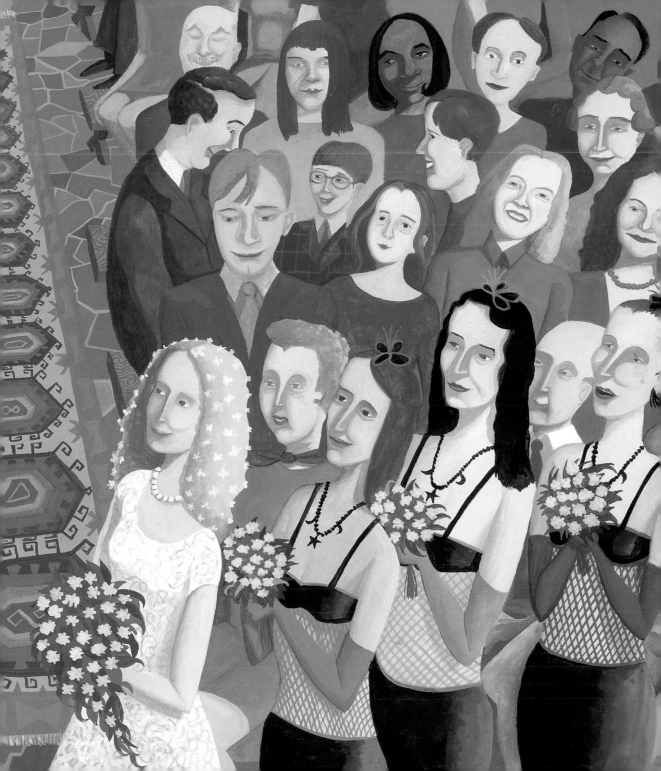

LORRAINE
I'm George's wife.
I don't know what happened to him.

TED
Oh, really? I thought—

LORRAINE
You're probably thinking of one of the other
wives. I'm the fourth one.

TED
No, no. I wasn't thinking . . . I'm not really
sure . . . But that's fine. That's just fine.

LORRAINE
I'm the only one who really works. I don't
count what those other women do as work.

TED
Well, that certainly sounds like a good idea.

LORRAINE
Some people, they look at me, and all they see
is a kid. They think, oh, she's so much younger
than her husband, she must be a bimbo. They
don't see how serious I am.

TED
You are not exactly old. In all honesty, I have
to say that. But I don't mean it in a bad way.
Age means different things to different people.

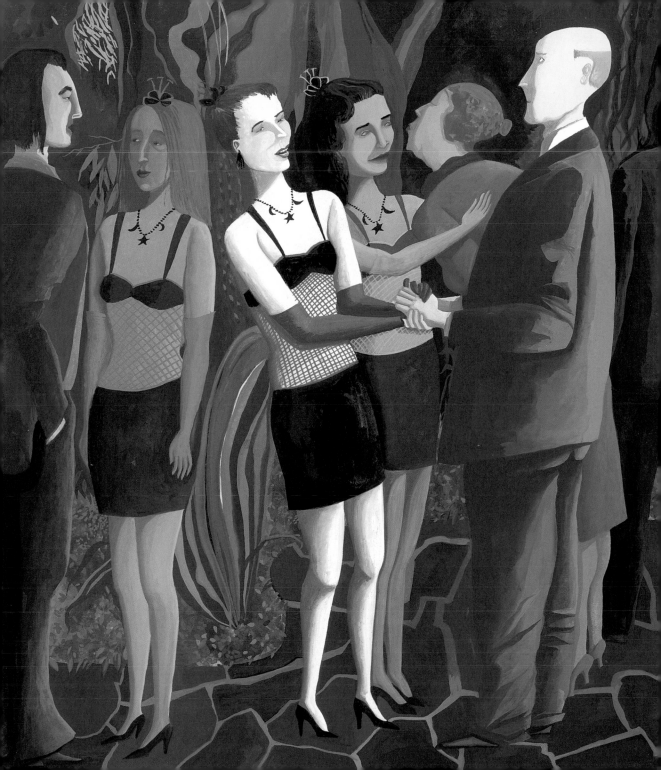

LORRAINE

I'm a nurse, you know, and a nurse sees a lot.
You grow up fast. I see more about life in a day
than George sees in a year.

TED

A nurse. Now that's interesting. When I was
at the hospital for my cholesterol test I noticed
that they use a lot of wires these days. I don't
recall them using so many in the past. There
was a man there who had wires sticking out
of his chest and wires sticking out of his arms.
Wires everywhere. I got a glimpse of him as I
walked by, and I had to look away. Although
I'm sure it was all necessary. Have you noticed
an increase in the use of wires?

LORRAINE

Wires? I can't think of any reason—

TED

All over the body. Out the front, out the back.

LORRAINE

I don't know. You can wire a jaw shut . . .

TED

No, no. There are a lot of these people, and
they bristle with hardware.

LORRAINE

I'm really just a pediatric nurse.

TED

Wires in the neck, especially.

* * *

BILLY
Such a nice day for a wedding.

KIP
Yes! Of course! No secret there!

BILLY
I know that you and Bonnie will be as happy
as Fay and I have been.

KIP
Well, that would be wonderful. I mean, I know
how happy . . . you and Fay, uh, have been.

BILLY
What's that on your face?

KIP
Nothing!

BILLY
Up here.

KIP
My face is just the same old face I've always
had, I swear.

BILLY
Look, it's a petal.

KIP
Oh. A petal.

EXPERIMENTAL
RM. 912

CAUTION

CAUTION

DANGER

RADIA
& INDUS
HAZARD

CONTROLLED
AREA

TOXIC

BILLY
That's what you get for tying the knot
in a greenhouse.

KIP
Yeah, well, Bonnie cooked up quite a
wedding here.

BILLY
I've never seen such sexy bridesmaid dresses.

KIP
That's for sure.

BILLY
The bride looks so different from her atten-
dants. Not that she's not . . . The dress is so
traditional, I mean.

KIP
Oh, that's just coincidence.

BILLY
Coincidence?

KIP
That, you know, they're wearing such different
outfits. You can't read anything into it.

BILLY
I know. Fay and Bonnie are very similar, under
the surface.

KIP
You really think so?

BILLY
I'm going to tell you the secret to a successful
marriage.

KIP
What's that?

BILLY
Marry the most beautiful, exciting woman
you've ever seen.

KIP
I've already done that.

BILLY
You'll never get tired of her. But you'll spend the
rest of your life worrying that you're going to
lose her.

* * *

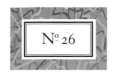

KITTY
It's a beautiful day for a wedding, isn't it?

MAYBELLINE
Marvelous.

TANSY
A good omen, I think.

KITTY
Yes, they're going to be very happy . . .

MAYBELLINE
There's so much light. You could wear
sunglasses in here.

TANSY
That's one advantage of having a wedding in
a greenhouse.

KITTY
But it's funny, all the songs they're playing seem
to be about the moon.

TANSY
You must be Kip's cousins, right? The ones
from Pittsburgh?

MAYBELLINE
No, we're friends of Bonnie's.

TANSY
Oh, really? I'm her sister.

KITTY
Well, we're more colleagues.

TANSY
Lawyers. Of course. I see.

KITTY
Lawyers! No, we're not lawyers.

TANSY
Ah. Someone told me it's the legal secretaries
who do all the work. Is that true?

KITTY
I don't know. I don't think so.

TANSY
You're not secretaries?

MAYBELLINE
We're actresses. Bonnie represents us.

KITTY
She's incredibly good. Sometimes I actually
look forward to going to court.

TANSY

I'm not surprised at all. I mean, I'm sure she's excellent. You know, it was my idea to have the wedding here. I suppose it's a touch unconventional, but Bonnie has always been very open-minded. That is, she's always been open to different . . . things. And now I'm a little sorry, because the place reminds me so much of work. This is where *I* work. Not that . . . of course I'm not really sorry I had the idea, but it's too bad to be at a festive occasion and keep thinking about your job.

KITTY

I know what you mean. Maybelline and I wore outfits like yours in—what was the title?

MAYBELLINE

Dial 69.

KITTY

Yeah. What a pain. It was hard to keep that much stocking from running.

* * *

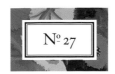

KIP
If you could live anywhere, where would it be?

JULIE
Next to Bonnie.

KIP
Good answer. But in a wonderful, romantic
place, right?

JULIE
Like a castle?

KIP
Maybe a villa.

JULIE
I'd like to live in a castle. Next to Bonnie's.

KIP
That would be perfect, since you both remind
me of princesses. You dance very well, you
know.

JULIE
I take lessons.

KIP
Ah.

JULIE
But we don't do anything like this.

KIP
No twirling?

JULIE
All we do is bend.

KIP
What do you think of Italy?

JULIE
Well . . . what is it, exactly?

KIP
It's where Bonnie and I are going to live.

JULIE
Oh, that's right. I forgot.

KIP
No, she doesn't know yet. It's still a big
secret. I'm going to tell her tonight that I got
a job there.

JULIE
Really? I thought she sounded very excited
about it.

KIP
She is going to be thrilled.

* * *

N.º 28

FAY
I know he thinks I'm a snob, but it's not that I
don't want to dance with *him*. I'm afraid to
dance at all.

BONNIE
Why?

FAY
Billy says, well, that I'm not very good at it.

BONNIE
What?

FAY
I can't believe he didn't tell me before.

BONNIE
I suspect that one of the reasons he didn't tell
you is that it's not true.

FAY
No, no.

BONNIE
Fay, you won a dance contest. Don't you
remember?

FAY
Yeah. And the other person who won was
wearing a bunch of cardboard boxes as a
dancing train costume.

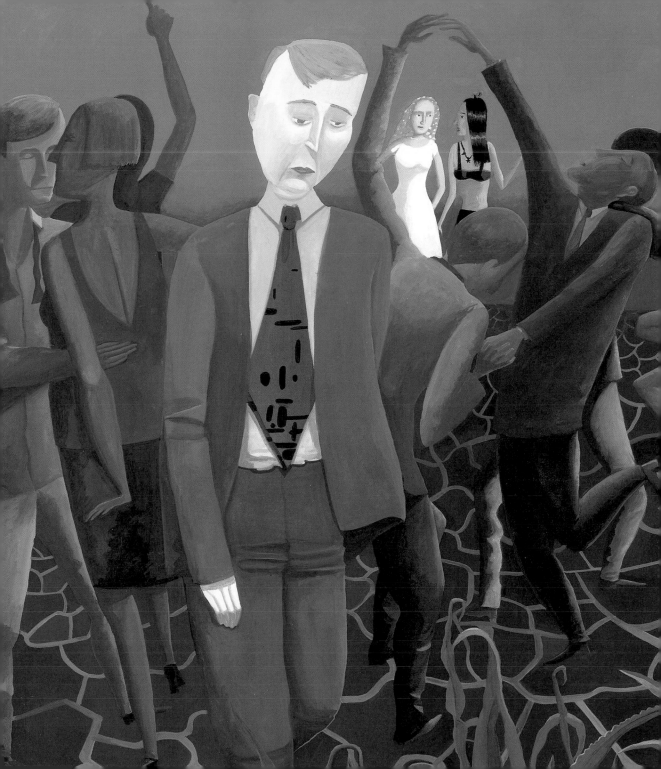

BONNIE
Okay, so you're not as good as Fred Astaire.
Does that make you feel any better?

FAY
You really don't think I'm a bad dancer?

BONNIE
Of course not.

FAY
I bet George is a good dancer.

BONNIE
Oh, God.

FAY
But then, George would never care if I ruined
my image making a fool of myself in public.

BONNIE
I don't think he'd notice. He's far too
self-involved.

FAY
I know. But the question is, when am I most
myself? When I'm being a good little girl with
Billy? Or when I'm being an insufferable
hypocrite with George?

BONNIE
It's funny, I find that I'm most myself when
I'm thinking about something totally different.

* * *

GEORGE
Tansy . . . that outfit.

TANSY
It's the same as your wife's.

GEORGE
I've just never seen you look so lovely.

TANSY
And Fay's. It's the same as Fay's.

GEORGE
I know.

TANSY
Well . . .

GEORGE
Tell me what you're working on these days.

TANSY
Protein formation.

GEORGE
I see. Have you noticed in the course of your studies that everything in the world is either a rod or a circle?

TANSY
Not really.

GEORGE
Coupling is universal. Look at this equipment. Each piece either penetrates or contains.

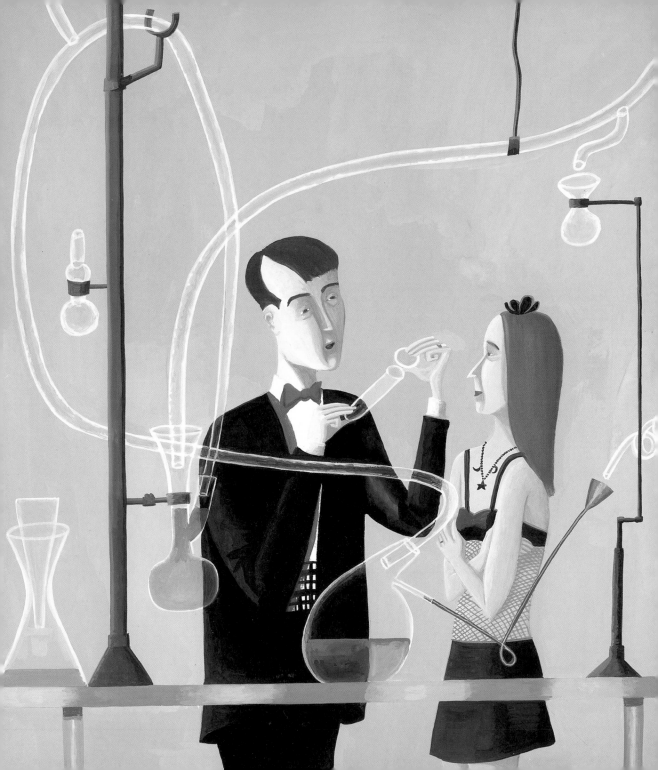

TANSY
Sort of.

GEORGE
This penetrates . . . this contains . . .
this contains.

TANSY
I suppose you could say that the computer
contains information, but it would be a bit
of a stretch.

GEORGE
The two things correspond to the structure
of our thought, to the very deepest part of
ourselves. You know what I'm talking about,
don't you?

TANSY
I think I've got the general idea.

GEORGE
A waterfall penetrates; a pool contains. A finger
penetrates; a glove contains.

TANSY
How about a parachute?

GEORGE
Penetrates. Nice and slowly.

TANSY
Ah.

GEORGE
What do you think I'd be?

TANSY
That's not hard to guess.

GEORGE
Hey, women line up for such penetration.

* * *

BONNIE
What are George and Tansy talking about?

KIP
How should I know?

BONNIE
I thought you might have overheard something.
I think I did.

KIP
What? What did you hear?

BONNIE
I'm not sure.

KIP
I don't get it.

BONNIE
I think they were talking about rods and circles.
If you know what I mean.

KIP
Not exactly.

BONNIE
We're doomed!

KIP
Bonnie!

BONNIE
. . .

KIP
Bonnie, please. You've got to be honest
with me.

BONNIE
Yes, yes.

KIP
Do you find George attractive?

BONNIE
God, no! Absolutely not! I would never!

KIP
Then what are you staring at?

BONNIE
The future.

* * *

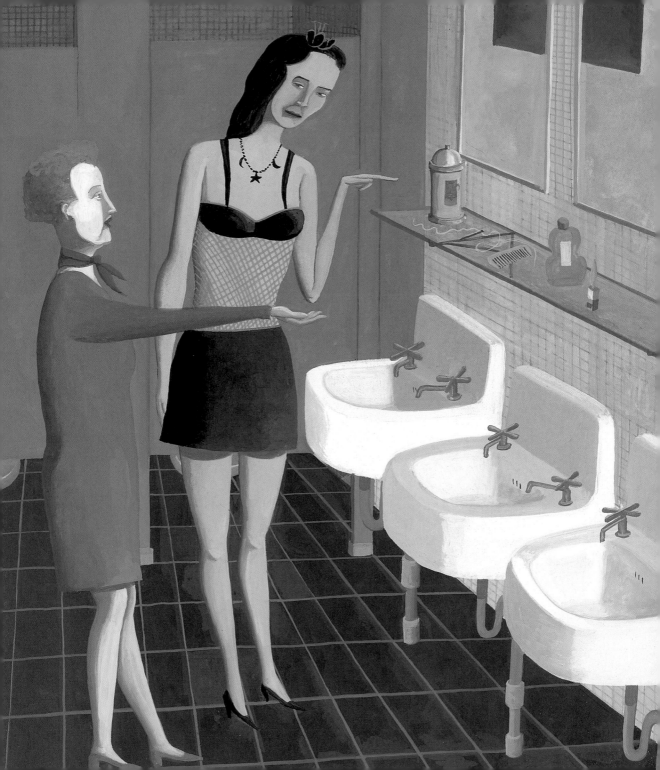

HELEN
Fay. I didn't get a chance to congratulate you yesterday. You're a big star now.

FAY
Oh, a little star.

HELEN
You must meet a lot of fancy people.

FAY
That's my job, after all. But I try to vary my programs. I just did a segment on volunteerism.

HELEN
Who was the most famous person you ever met?

FAY
Well, let me think.

HELEN
I wanted you to meet my friend Marguerite Vollman, but she couldn't come.

FAY
Mrs. Vollman? The one with the dog? I didn't know you were friends.

HELEN
We're very close. You look so much better than the last time I saw you.

FAY
When was that?

HELEN
Christmas. A few years ago. You'd just
gotten fired.

FAY
Oh, yes.

HELEN
I told you at the time that something was bound
to come along, and, sure enough, it did.

FAY
That was seven years ago, actually.
Maybe eight.

HELEN
You were asking Bonnie about law school,
but I told you to have faith in yourself.

FAY
Look at all this stuff. Hairspray, comb, needle
and thread, clear nail polish, and mouthwash!
Just looking at it makes me feel like I'm
unraveling.

HELEN
Well, you don't have to use it. I just thought it
might come in handy.

FAY

Oh! You put it out. A little bit of hairspray.
Yes, that would be nice.

HELEN

I'd always thought it was customary to provide
these things.

FAY

Yes, yes. Have to do it. Otherwise, what if
someone . . . came unglued?

HELEN

I'm not really sure.

FAY

It could happen, you know.

HELEN

Fay, are you all right?

FAY

Of course, of course. Nothing that a little needle
and thread won't cure.

*　*　*

GEORGE

Kip and I go far back as anybody. I've admired
him ever since he streaked my kindergarten
class at the age of two. Does anyone remember
streaking? I'm dating myself now. (Probably the
only person in the room I haven't dated!)
Anyway, I've always had three years on Kip,
and that has given me certain rights and respon-
sibilities. In high school he may have been cap-
tain of the track team and president of his class,
but when he went to his first dance, I said, "Kip,
your socks don't match," and he was up those
stairs in a flash. You might say I'm an expert on
things marital—in fact, I have as many mar-
riages on my brother as I do years—and I can
say without qualification, because I checked
them earlier, "Kip, today your socks match."

SONNY

I'm not much of a speechmaker, but I do feel I
can add some perspective here. Kip gave me my
first job in PR. I was young and untried, and
there was no reason he should have handed me
as much responsibility as he did. Kip, there is
one thing I've been meaning to say all these
years: Why? Why did you do it to me?

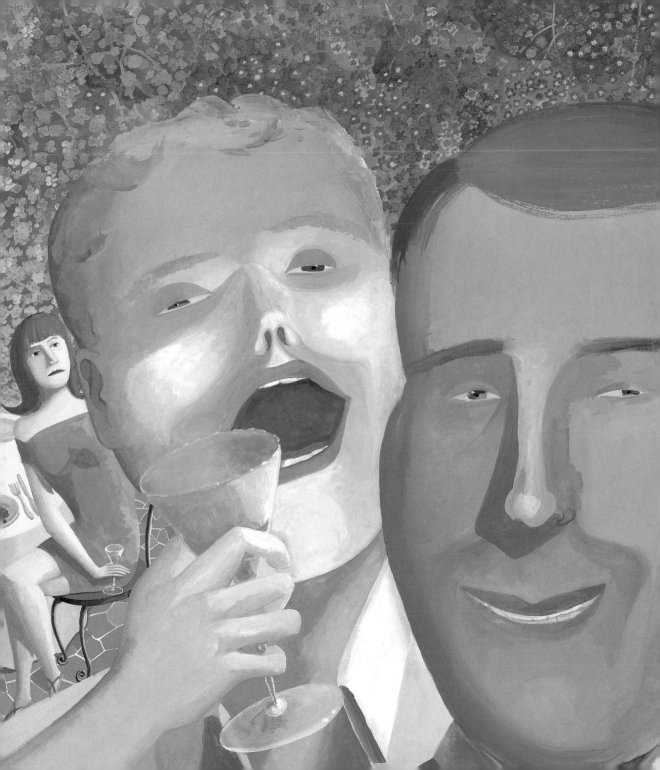

TANSY

Ah, I want to offer a toast, just a plain toast.
That's it. Nothing else. So there it is.

RICKY

I'm going to start out with a story. A couple of
months ago now a certain fellow came into my
office and said, "I'm going to get married," and
I said, "Oh, really, when?" and he said, "In
June." I suppose by now you've all guessed I'm
talking about Kip. That's just the kind of guy he
is. Good luck, Kip! You're one in a million!

PETE

Bonnie, don't let these goobers fool you. Kip
was the most popular guy at the office. You
don't hear a lot about love from the male sex,
because they're afraid people will get the wrong
idea, but I for one am not ashamed to say it:
Every single man in our office loved Kip. And I
don't care if you would call it gang rape. We
wouldn't have traded a minute of it for the
entire football pool. Especially now that Kip's
gone, and it's shrunk so disastrously. Let's all
say it: Kip, we love you! We'll never forget you!

* * *

BONNIE
Do you feel married yet?

KIP
I'm not sure.

BONNIE
Tansy said I wouldn't feel any different, but I do. I feel all . . . light-headed, I feel so happy.

KIP
Me, too. I'm bursting to tell you my surprise.

BONNIE
So what is it?

KIP
No, no. I don't want to ruin it. I'm going to be strong.

BONNIE
I just heard Mr. Lebhardt tell Mrs. Lebhardt that he would marry her all over again.

KIP
But if you *guessed*, that would be different.

BONNIE
You mean your surprise? I can't imagine anything nicer than those green leather gloves you got me in Florence.

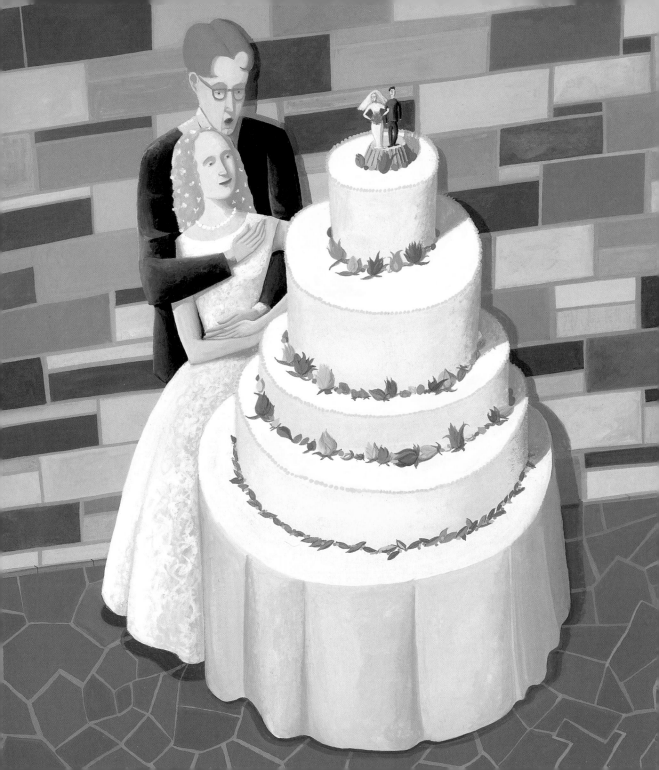

KIP
I'll give you a hint. It's kind of like that,
only better.

BONNIE
Boots?

KIP
It's a kind of boot!

BONNIE
Wait a minute. I think they delivered the wrong
cake. This looks big enough to fit a person
inside.

KIP
She can help you guess.

BONNIE
Okay. It's like boots. Well, shoes, then.

KIP
No, no. You'll never get it.

BONNIE
This does not look like carrot cake to me.

KIP
It certainly doesn't look very orange. You
know, Julie and I were talking about Italy
while we danced.

BONNIE
You were! What did she say?

KIP

Oh, nothing much. It's funny, how everything reminds me of Italy these days.

BONNIE

Me, too.

KIP

You're kidding.

BONNIE

See, we really are married.

* * *

TANSY
That George. He sure gets around.

BONNIE
Oh, Tansy. What happened?

TANSY
I think he came on to me.

BONNIE
I'm sure he did.

TANSY
It's kind of hard to believe now. But it was immensely flattering at the time.

BONNIE
I gather you turned him down.

TANSY
I think so. It was all done in some kind of spacey code, but I think so.

BONNIE
Thank God you didn't sleep with him in a second, the way you said you would.

TANSY
If the whole thing really could have taken just a second, I might have done it. That's what I would have needed—a disconnected moment. But all my moments are connected to Walter, one way or another.

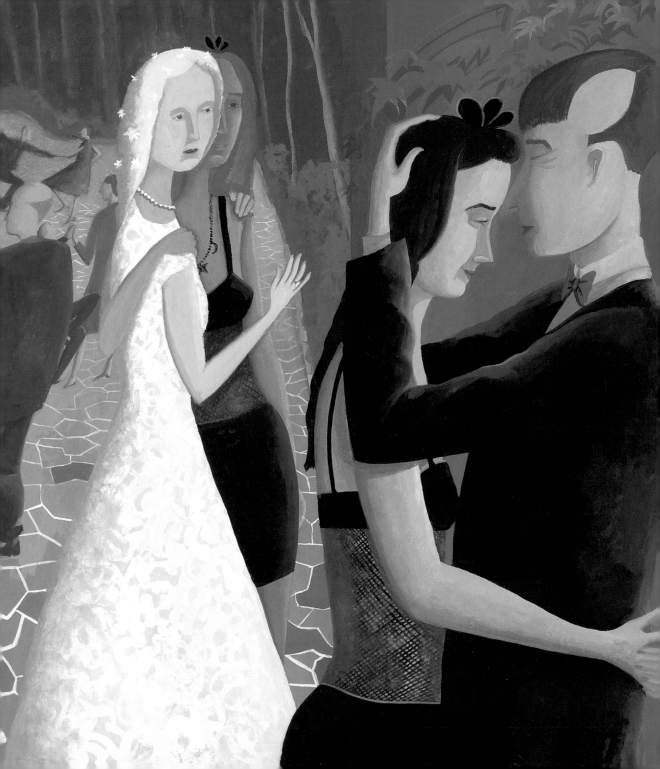

BONNIE
Maybe all of George's moments are
disconnected. He's not really such a bad guy.

TANSY
I can't believe he asked Fay to dance, though.
What incredibly bad taste.

BONNIE
He didn't ask her. She asked him.

TANSY
Really? Good for her.

BONNIE
Yes, I love to see women behave badly.

TANSY
It's only fair.

BONNIE
After all these years.

TANSY
I guess I've let our side down.

BONNIE
No, no. I've never seen the point of applying
a general principle to yourself.

TANSY
And you're supposed to be a lawyer.

BONNIE
That's why I know the law has nothing to
do with real life.

* * *

HELEN

Do you remember the supper club on the lake where we went on our honeymoon?

TED

We never went on a honeymoon.

HELEN

Well, we may never have gone on a fabulous cruise. But we went away for the weekend.

TED

Of course, of course. We went to Jack's cabin in Pennsylvania.

HELEN

Mmm. Jack Hyman's cabin. I at least had the sense not to tell my mother his name. But you went forging ahead.

TED

Jack Hyman? Oh, yes. I never noticed.

HELEN

Maybe.

TED

Your mother didn't listen to anyone, anyway.

HELEN

And it was in Vermont, not Pennsylvania.

TED

Jack never had a cabin in Vermont.

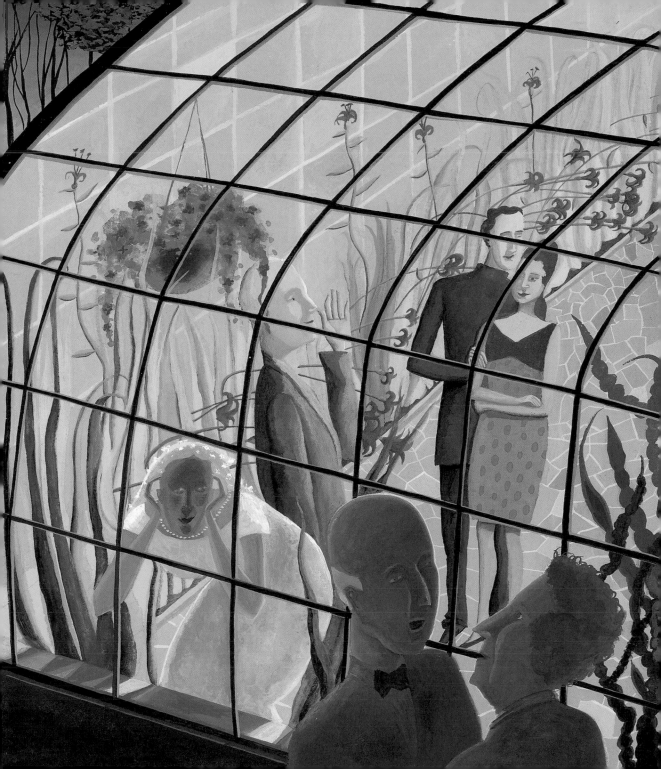

HELEN
I don't know anything about Jack's real estate.
None of his investments amounted to much, as
I recall. But I do know that the cabin we went to
was in Vermont. On a lake. And we danced at a
supper club at the edge of the water.

TED
Look at the logic of it. If *A* never had a
cabin in *B*, and we stayed in *A's* cabin, then
we weren't in *B*.

HELEN
I can't believe you don't remember our
honeymoon.

TED
I remember the little gold chain.

HELEN
What?

TED
The little gold chain you wore around your neck.

HELEN
The little gold chain.

TED
Don't you remember? It had the littlest links
I ever saw.

HELEN
Yes, I remember . . . I remember you shaved
your beard again at night, so my face wouldn't
get scraped.

* * *

FAY
So how was I?

BILLY
You certainly looked like you were having
a good time.

FAY
At least I didn't trip over my feet.

BILLY
I'm amazed you did as well as you did,
considering your partner.

FAY
You don't think he danced well?

BILLY
No.

FAY
I suppose I embarrassed you.

BILLY
No, no. You could never embarrass me.
I just said dancing wasn't your strong suit.

FAY
Uh, huh.

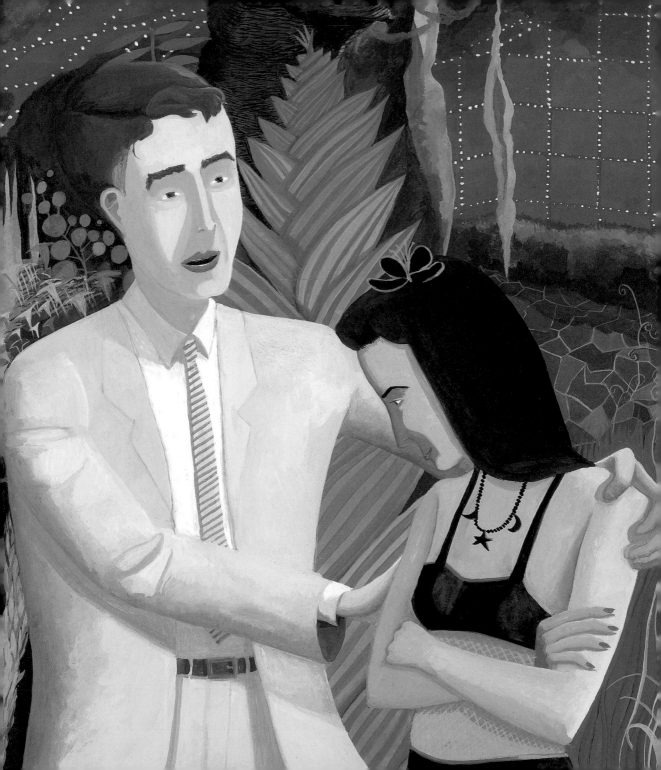

BILLY
All I meant was that there are so many other things that you are best at in the world.

FAY
Like what?

BILLY
Like . . . like being yourself.

FAY
How interesting, that you would say that. But sometimes, when I'm being myself, I dance.

BILLY
Do you know George very well?

FAY
He's Kip's brother.

BILLY
I know. But he has kind of a bad reputation.

FAY
Oh?

BILLY
With women, I mean.

FAY
He seems like a perfectly okay guy to me.

BILLY
Fay, you're never going to leave me, are you?

FAY
Of course not.

BILLY
Really?

FAY
Well, I suppose . . . yes, I don't think I'll ever
leave you.

BILLY
I couldn't bear it if you did. The thought of
going out with other, ordinary women now that
I've known you is absurd.

FAY
Oh, Billy. You really believe it, don't you?
That other women are ordinary, I mean, and
that I'm not.

BILLY
Because it's true.

FAY
You've always made me believe it, too.

BILLY
Thank God.

FAY
So let's go get another glass of champagne.

BILLY
But don't you think you've had enough?

* * *

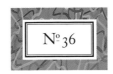

WALTER
You're saying I'm wonderful? Is that what
you're saying?

TANSY
You sound like you don't believe me.

WALTER
But last weekend you told me I was the worst
person in the world.

TANSY
I never said that.

WALTER
I barely crawled out of that argument alive.

TANSY
Oh, God.

WALTER
So which do you really think?

TANSY
I don't know why you always remember the
bad during the good and never the good during
the bad.

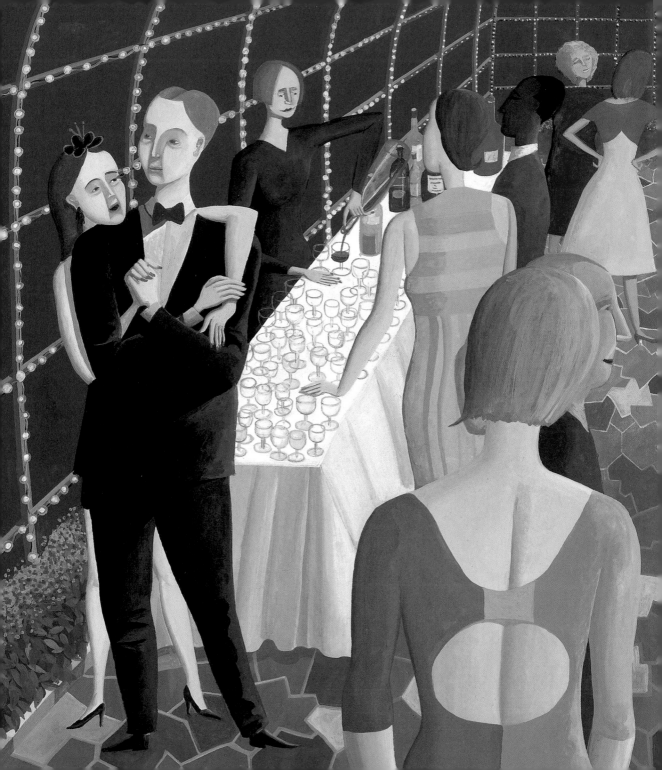

WALTER
Am I the best? Or the worst?

TANSY
Remind me never to compliment you again.

WALTER
Just tell me how I can be the best person
and the worst person.

TANSY
Maybe you're the only person.

* * *

TANSY
So does Italy penetrate or contain?

GEORGE
Oh, Kip told you about Italy, too?

TANSY
He doesn't know yet. Bonnie's going to surprise him tonight. She just got a job there.

GEORGE
But so did he! This is incredible! A good job?

TANSY
At the embassy.

GEORGE
Wow.

TANSY
They really will live happily ever after.

GEORGE
Yeah.

TANSY
Makes you believe in something.

GEORGE
Something?

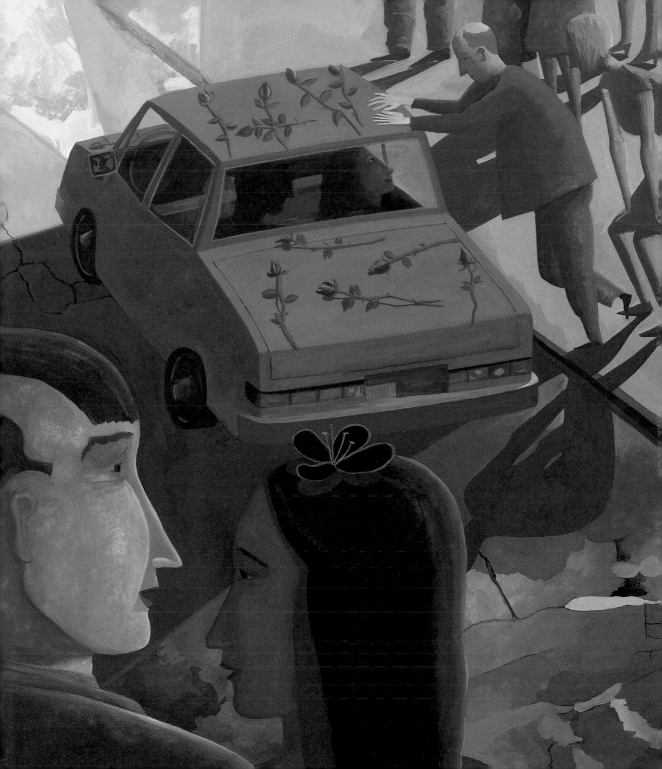

TANSY
You know what I mean.

GEORGE
I do, actually.

TANSY
And Rome is supposed to be so beautiful.

GEORGE
Rome? Kip got a job in Milan.

TANSY
Uh, oh.

GEORGE
Bonnie's going to Rome?

TANSY
Yup.

GEORGE
Well, Italy penetrates. Definitely.

* * *